MONOGRAMS
&·CIPHERS

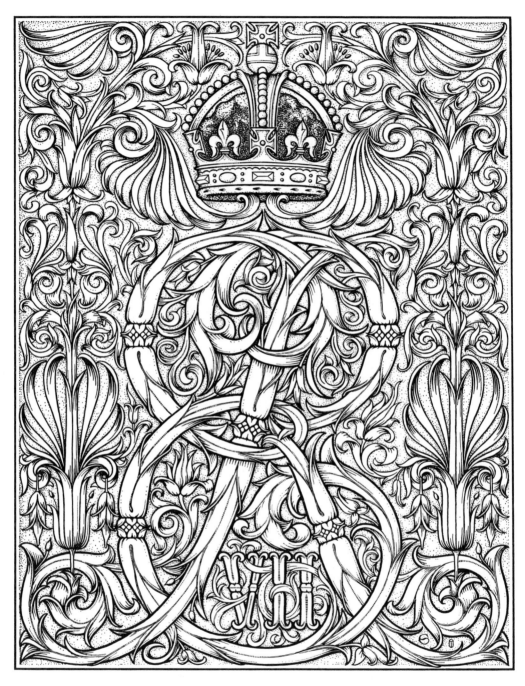

ROYAL CIPHER

MONOGRAMS & CIPHERS

Designed and Drawn by

A. A. TURBAYNE

AND OTHER MEMBERS OF
THE CARLTON STUDIO

DOVER PUBLICATIONS, INC., NEW YORK

This Dover edition, first published in 1968, is an unabridged and unaltered republication of the work originally published by T. C. & E. C. Jack, Edinburgh, circa 1906.

International Standard Book Number: 0-486-22182-2
Library of Congress Catalog Card Number: 68-55285

Manufactured in the United States of America

DOVER PUBLICATIONS, INC.
180 Varick Street
New York, N. Y. 10014

INTRODUCTORY NOTE

I N laying out this book I have put into it the experience of many years of actual work in the designing of Monograms, Ciphers, Trade-Marks, and other letter devices. I have given the work much careful thought in order to present the most useful material, to give that material on a good workable scale, and in such a way that any design can be quickly found. By the arrangement of the designs the plates form their own index. On Plate II will be found combinations of AA, AB, AC; on Plate III combinations of AC, AD; on Plate IV, AE, AF, AG, etc. A device of MB would be looked for under the letter of the alphabet first in order, B; it will thus be found in the BM combinations on Plate XVI.

Now the letters AA have only one reading; two different letters, AB, can be read in two ways; while AAB can be read in three ways; and ABC, or any three different letters, can be placed to read in six ways.

A complete series of designs, AA, AB, BA, AC, CA, to ZZ, would run to 676 devices; add to this a series with a repeated letter, which would be the next in order, giving one reading only, AAB, BBA, etc., of which there are 650, and we get 1326 combinations. This would require, if carried out with nine

designs on a plate, 147 plates. Our book was not to exceed 135 plates, and in addition to as complete a series as possible of two-letter designs, there were to be included some plates of sacred devices, designs of three different letters, and other matter which would make a work of practical use.

By limiting the number of combinations containing the I and J, and the O and Q, which can easily be made interchangeable in the working, and giving but a single reading of most of the devices containing the letters X, Y, Z, which will be the least used, I have been able to present a good working selection of two letters and a repeated letter in 113 plates.

Three different letters, as I have stated, can be read in six ways. Take, for instance, the first three letters of the alphabet, and we have—

ABC	BAC	CAB
ACB	BCA	CBA

Add a fourth letter to the three, and we have four times six, or twenty-four readings, as follows :—

ABCD	BACD	CABD	DABC
ABDC	BADC	CADB	DACB
ACBD	BCAD	CBAD	DBAC
ACDB	BCDA	CBDA	DBCA
ADBC	BDAC	CDAB	DCAB
ADCB	BDCA	CDBA	DCBA

INTRODUCTORY NOTE

It will thus be seen that books advertised as made up of three- and four-letter combinations must be very fragmentary, as anything like a complete work of these units would run to an enormous length.

Now let us see what a work of three-letter designs would mean. ABC, ABD, etc., giving an alphabet of one reading only, would run to 2600 designs. A book of this sort would be of little use, as the design looked for would probably not be there, for every one of these 2600 groups can be placed to read six different ways; and to make a complete work of three-letter designs, with no repeat letters even, would require a showing of 15,600 Monograms or Ciphers. But what about the three letters, one of which is a repeat? A glance through any list of persons will show that these have a right to be included, though they do not occur as frequently as three different letters. Add these to the list for a complete three-letter book—there are 1976 of them, including 26 combinations where the three letters are the same, AAA, etc.—and we have 17,576 designs to be shown. Following the plan of nine designs on a plate, we would require 1953 plates, making a work of fourteen volumes the size of the present book. A bulky work of this sort would not only be unpractical, but the cost of production and the price at which such a work could be sold, would place it beyond the reach of most of those workers to whom we hope to appeal.

In the plan I have adopted the book is practically a complete

work of two-letter combinations in a single volume. A device of any two letters will always be readily found, which should be sufficient to furnish the designer or artisan with a base upon which to build a design of three or more letters.

There is to-day a growing taste for severe chaste forms in printing types and lettering; the same influence is also directing a change of style in the more decorative Monogram and Cipher. The florid combinations of the last two centuries are gradually falling into disuse, and are giving place to the very simplest forms. The aim of the present work is towards simplicity, but in order that the book may appeal to various tastes, and thus be of greater value, examples of many styles are included.

Each of these styles, while based on some familiar form which has long been in use, has had its pruning, and as much of the superfluous flourish not necessary to letter or design has been discarded.

The styles included may be classed under five principal heads—Roman, Gothic, Sans Serif, Cursive or Running, and what I might call Rustic. These styles are treated in various ways, and in light and heavy letters. Here and there throughout the work a design will be found that may suggest a treatment for some particular device. These are odd pieces that have occurred to me as the plates were in progress, the execution of most of which would probably be more satisfactory in embroidery than any other medium. There are three principal forms of treating

INTRODUCTORY NOTE

a device; I will call them the Imposed, Extended, and the Continuous forms. By the Imposed form I mean a design where the letters are written or interlaced directly over one another. In the Extended form the letters are interlaced or written side by side. In the Continuous form the device runs from beginning to end without a break. In the Imposed form the principal letter, whether it is first or final, should be accentuated, either by making it slightly larger, heavier, or in some other way best suited to the material in which it is being produced, it may be colour or texture. For the Extended form, if the letters are to be read in the order in which they follow one another, all may be treated alike. In this form, however, it is often advisable, for design and balance, especially when filling a circular space, to place the principal letter in the centre; in that case it may be drawn larger, and in some other way made more important. The Continuous form should read as the letters would be written, and care must be taken to place them so that they will not appear to read in some other way. It is intended that the Monograms and Ciphers shown in the following plates be considered as outlines only, as models or working drawings. The solid or tint grounds need not be taken as part of the design; they are intended to show which are planned in a round, and which in a square panel. There are but a few cases in which any detail is given that would apply to a particular craft, or suggest the material in which they are to be worked. Each artist or craftsman can use the forms, supplying his own

detail to suit the technique of the work in hand. By this means the book should be equally useful to any craft. With this broad rendering it will be noticed that some of the designs do not appear to read in the order described; in such cases the important letter requires that detail which I have suggested in some instances with a tint or black. The order of description is followed throughout the book for the sake of easy reference; it is only departed from in a few places where one reading only is intended, as in the LRR on Plate LXXXIV, the continuous Monogram NMN on Plate LXXXVII, and the continuous Cipher WTW on Plate CX.

Before proceeding further I should state the difference between a Monogram and a Cipher. This is necessary, as the two devices are constantly being miscalled; some authorities too, while correctly describing a Monogram, give a Cipher for illustration. A Monogram is a combination of two or more letters, in which one letter forms part of another and cannot be separated from the whole. A Cipher is merely an interlacing or placing together of two or more letters, being in no way dependent for their parts on other of the letters.

Of the two classes Monograms are the more interesting, probably on account of their being more difficult to plan, though I think they are rarely as pleasing to the eye as the Cipher, except in the very severest forms. Compare the whole plate of Ciphers, CXIV, with the next plate, CXV, composed entirely of Monograms.

The difficulty in designing Monograms does not so often lie

xiv

in being able to plan the Monogram, as in being able to produce one that will be read by others, and where all the letters will read, and those only that are intended. When we begin to put two or three letters together that are made up of one another into a single unit, other letters are suggested or occur in the device not intended; or again, two or three of the letters will be so apparent that the third or fourth will only be known to the designer or owner. Take, for instance, the PQR on Plate cxv; the small device is the better one of the two, but few will read it other than PQ, QR, or PR. Personally I prefer a design that is a little obscure, if the lines are good, if it is a fine piece of ornament.

A Monogram or Cipher is in all cases intended for ornament, whether used as a mark of ownership by private individuals, or for a company, or a trade-mark. For purposes of commerce it is of course important that the device should be distinct and easily read. The same might apply also to the design for a club or society mark. For private use, however, where the device is to enrich a piece of jewellery, plate, the binding of a book, a piece of furniture, or part of the decoration of a house, it should in the first place be a good design. If the conceit is legible to the owner, and is of such fine proportion as to be thoroughly satisfying to the eye, why should it read like an advertisement, or be like 'Everything in the shop marked in plain figures'?

Some of the most beautiful Ciphers I have seen are to be found on old French bindings, many of which would be unintelligible if

we did not know for whom the books were bound. These Ciphers form in many instances the sole decoration of the binding, sometimes but a single impression appearing on each side, yet the book satisfies one as being perfectly decorated. This is so often the case with the Monogram and Cipher—it may be the only ornament that is to enrich a fine piece of workmanship—that in such places it should be a piece of choice design.

This brings us to that disputed point in this branch of art, the reversing of letters. For my own part I have no hesitation whatever in reversing a letter, or turning it upside down, or any other way, if it will produce a good piece of ornament. It is just as easy to fill a space, and fill it with good balance, with the letters facing as we are accustomed to see them, but this method will rarely produce that grace, beauty of line, and easy balance that letters of similar form turned toward one another will give. As an instance of this I would go no further than a single illustration which must be familiar to all—the Monogram HDD of Henry II and Diana of Poitiers—Henri Deux, Diane. It matters not where we find this, in the decoration of a ceiling, in enamel or painted ornament, or as a tooled book-binding, it has a dignity and feeling of easy repose that is never tiring. It would have been just as simple for the designer to have made a Monogram of these letters without reversing one of the D's, but no other possible arrangement would give the grace of line we find in this device. Another excuse for the reversing or turning upside down of a letter is, that when the

letters A, B, C, D, E, K, M, N, S, V, W, and Y occur repeated, you often get by turning a letter over or upside down a design that will read the same from all points of view. This advantage must be apparent to all, where the Monogram or Cipher is to be seen from different positions, as it will be, for instance, in the top of an inlaid table, a ceiling, a tiled or inlaid floor, or in the decoration of some small object like a finely bound book that will lie on a table, and on many a piece of the goldsmith's and silversmith's work.

The H, I, N, O, S, X, and Z can be drawn in Roman so as to appear the same upside down, and do not require to be turned over or stood on their heads; but with the letters A, M, V, W, and Y, though they will not require reversing where two occur in a combination, one will have to be turned upside down to make the design read the same from all points of view. If there are only the two letters, this will be simple, but if three or four letters are to be put together, it will depend on what the third or fourth letter is whether this is possible or not. I do not hold with doubling one of the letters in a device simply to turn over and make symmetry. If there is not a repeat letter, or a letter of similar form in the combination of letters to be put together, all letters should be doubled if symmetry, or reading from various points of view, must be had. On Plate LXXXV will be found a Cipher LT, planned without reversing to read the same upside down; a third letter, H, N, O, S, X, or Z, could be introduced without altering the LT, so that the combination of

three letters would read in the same way, whether looked at from the top or the bottom. There are but few letters that will plan in this way. When it is required of a design that it will read from all points of view, Roman letters will usually be found to give the most satisfactory result.

Intermixture of styles should always be avoided. If the Roman and Gothic are found too severe to suit a given subject, the Cursive and Rustic letters with their easy flowing lines can be made to fill almost any space one will be called upon to fill with either Monogram or Cipher.

A device besides being of one style of letter should also be pure as a whole; plan either a Monogram or a Cipher, but don't combine the two. The only excuse that might be advanced for the mongrel form, would be where a combination of three or more letters contained conjoined or hyphened words, represented by, say, AB-B or BC-D. Here the B-B and the C-D would form Monograms, the A and the B separate letters interlaced into them. I have given illustrations of this mixed device on Plate II, BBA; and on Plate XLII, EEO. For this last device there is no excuse, except as a trade-mark to be written quickly; a circle with three horizontal strokes, an upright stroke connecting the three in the centre, forming a solid device, EEO, on the lines of the Cipher FFO on Plate XLIX.

When planning a device avoid, if it is at all possible to do so, having three lines crossing at the same point, making three planes.

INTRODUCTORY NOTE

There is always a confusion in the interlacing if there are more than two planes, which produces a clumsy appearance in the design. There are cases when slanting or curved lines come across a straight line, where three crossings could only be avoided by contorting one of the letters ; in such a place it will be better to allow the three planes. Examples of Ciphers having three crossings at one point will be found on Plate XL, KE, Plate LXXXIX, MMT, and on Plate XCI, YM. Ciphers not interwoven, but placed side by side forming decorative lines, will be found on Plates XXIII, XXXIX, XLVII, and LX. One with the letters written one within another, a useful form for trademarks, is the CCG on Plate XXII.

A number of the plates have the nine designs carried out in one style. These should be useful as examples of the different characters of letters, as specimen pages for styles. I have grouped them under four heads as follows :—

ROMAN.

Plate LXXXI, light. Plate LXXXII, light, with cord and tassel. Plate LXXXVII, uniform stroke, small serifs. Plate XCVII, sans serif, with cord and tassel.

GOTHIC.

Plate XII, heavy. Plate LXXXVIII, light, pointed. Plate XCII, heavy, ending in leaf-forms. Plate XCIII, heavy, suggesting low relief, for stone- or wood-carving. Plate C, black-letter.

MONOGRAMS AND CIPHERS

CURSIVE.

Plates XIII and XV, foliated, embroidery. Plate LXXXIII, continuous. Plate LXXXIV, half-cursive, upright. Plate LXXXV, slanting. Plate LXXXVI, upright, uniform stroke. Plate XC, cursive-Roman, thin, uniform stroke. Plate XCIX, light, upright, flourish.

RUSTIC.

Plate XI, jewellery. Plate XX, two-colour. Plate XXXV, flourish. Plates XCI, XCIV, XCV, and XCVI, upright. Plate XCVIII, quill-rustic.

Monograms and Ciphers of three different letters will be found on Plates CXIV, CXV, and CXVI. On Plates CXVII to CXXI are firm-marks of two letters joined with the Ampersand, &. Plates CXXII to CXXVII show an alphabet with the '& Co.,' examples being given in round and square form. The last one of these plates contains also five examples of Numerals in Cipher, 1905, 1906, 1907, 1908, and 1909. Sacred Devices and Names fill Plates CXXVIII to CXXXII. Plates CXXXIII and CXXXIV are made up of Labels and three-letter Monograms. The letters for the Monograms are taken at random from a list of authors. The last plate, CXXXV, is a suggestion for the decorative treatment of Sacred Inscriptions in Monogram and Cipher, following the style of the Italian Renaissance.

One plate has been added to the work, engraved by

INTRODUCTORY NOTE

Mr. Thomas Moring, which shows some few ways in which these designs can be intelligently interpreted for a particular craft. It also shows how the character of a design may be preserved while a change is made in the letters or in their position. Plate L of the work was taken as the model. The PPF has been altered to EPF; the FQ transposed and made to read QF; FR to read FE; and RF to read RS. In the FFR the R has been made into a P, an R substituted for the reversed F, and with a slightly different treatment of the second F, the whole made to read RFP. In the sixth design the reversed R has been turned back, a very slight difference of treatment in all the letters being necessary to plan this well. The last three designs continue in the same way. A comparison of the engraved plate with Plate L will show with what little alteration a different character or reading can be introduced into a design.

I trust there will be found something in this book to please all tastes, if only a single device. For any errors there may be in the work I am alone responsible. In the drawing of the plates I have been ably assisted by different members of the studio. I am also indebted for the whole of Plate x. One error has passed me unnoticed till the part was published. What should have been DP, on Plate xxxiv, I have drawn OP; this, though a correct Cipher, is out of place on this plate.

<div align="right">A. A. TURBAYNE.</div>

CARLTON STUDIO,
LONDON, *March* 1906.

MONOGRAMS
&·CIPHERS

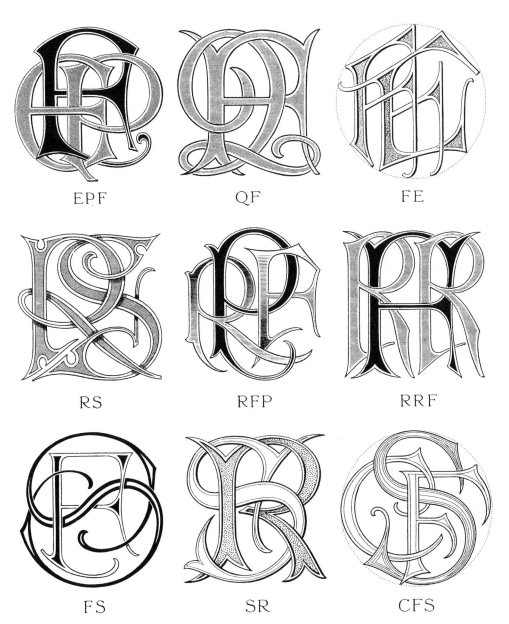

EPF

QF

FE

RS

RFP

RRF

FS

SR

CFS

SUGGESTIONS AS TO VARYING TREATMENT
BY THE ENGRAVER OF THE DESIGNS IN THIS WORK

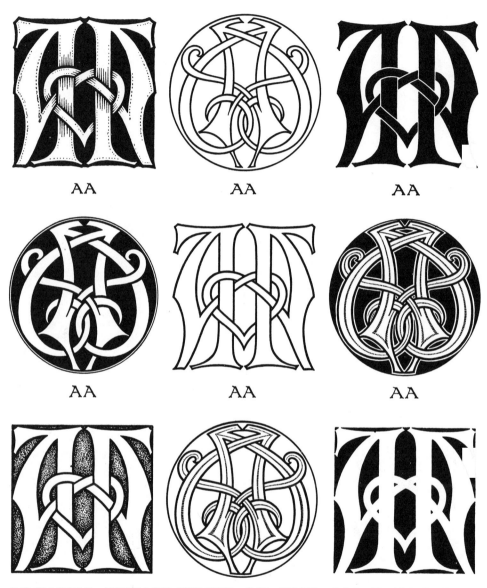

AA AA AA

AA AA AA

·VARIOUS·TREATMENTS·OF·THE·SAME·DESIGN·

6

PLATE I—AA

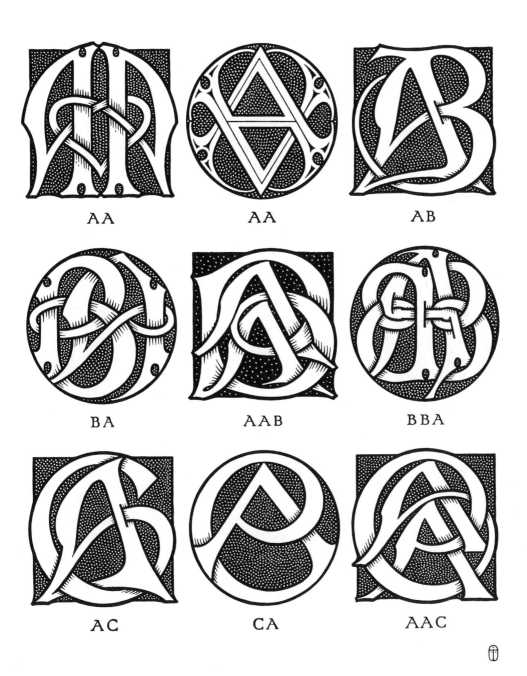

AA AA AB

BA AAB BBA

AC CA AAC

PLATE II—AA, AB, AC

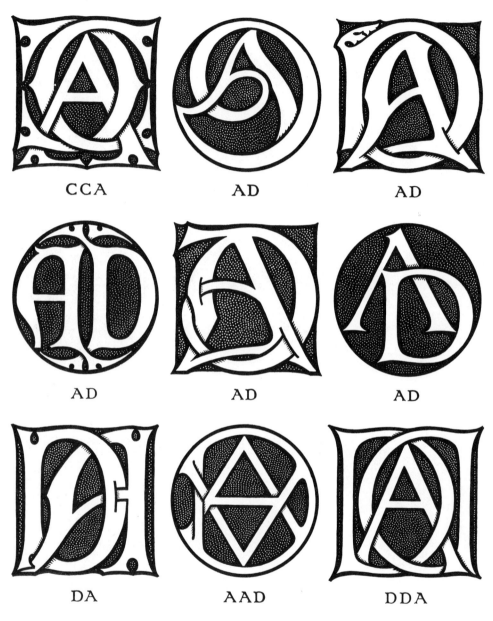

CCA AD AD

AD AD AD

DA AAD DDA

PLATE III—AC, AD

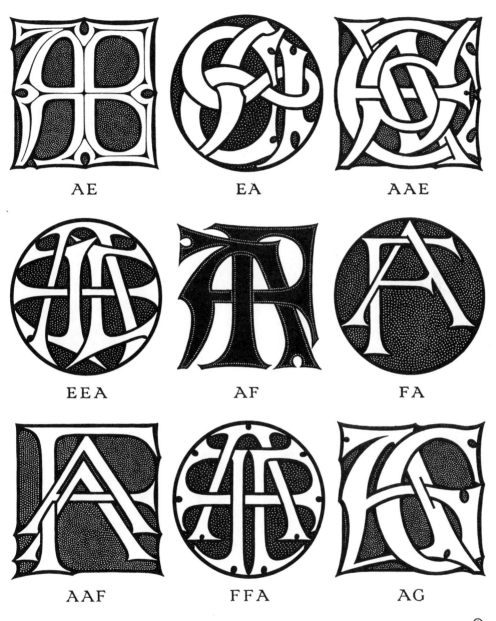

AE EA AAE

EEA AF FA

AAF FFA AG

PLATE IV—AE, AF, AG

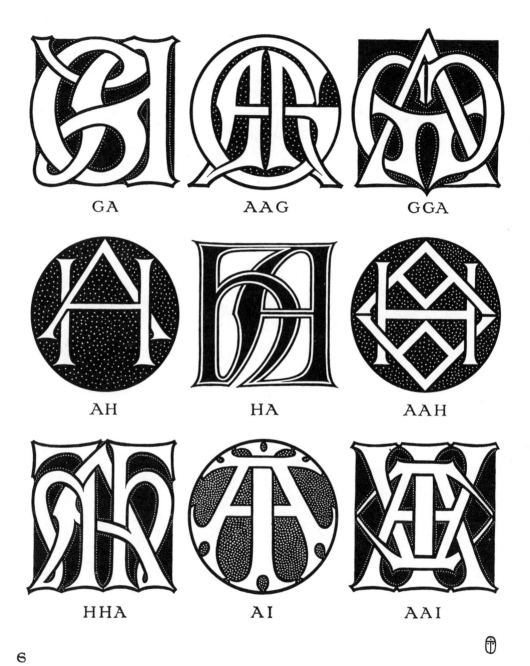

GA AAG GGA

AH HA AAH

HHA AI AAI

6

PLATE V—AG, AH, AI

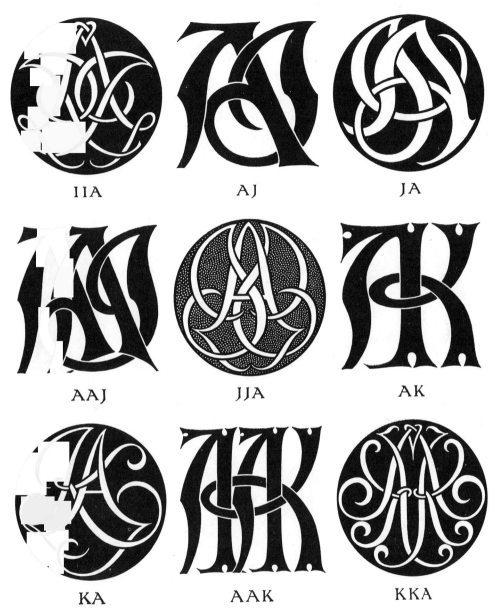

IIA AJ JA

AAJ JJA AK

KA AAK KKA

6

PLATE VI—AI, AJ, AK

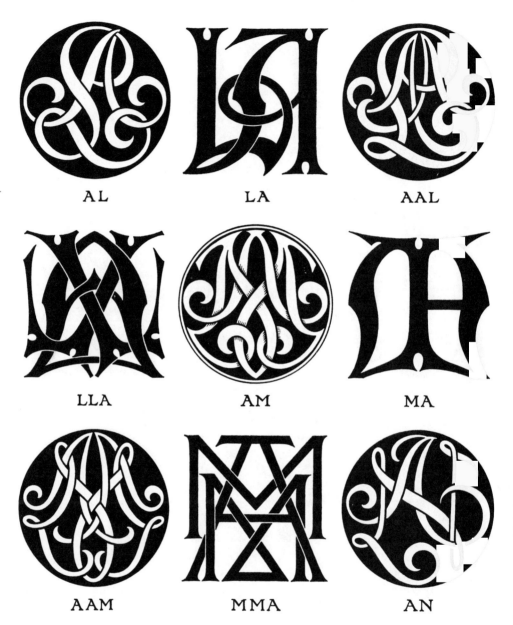

AL LA AAL

LLA AM MA

AAM MMA AN

PLATE VII—AL, AM, AN

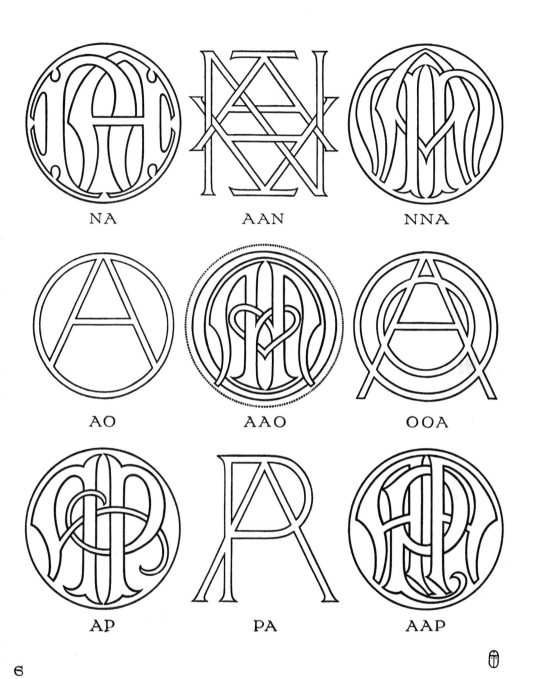

NA AAN NNA

AO AAO OOA

AP PA AAP

6

PLATE VIII—AN, AO, AP

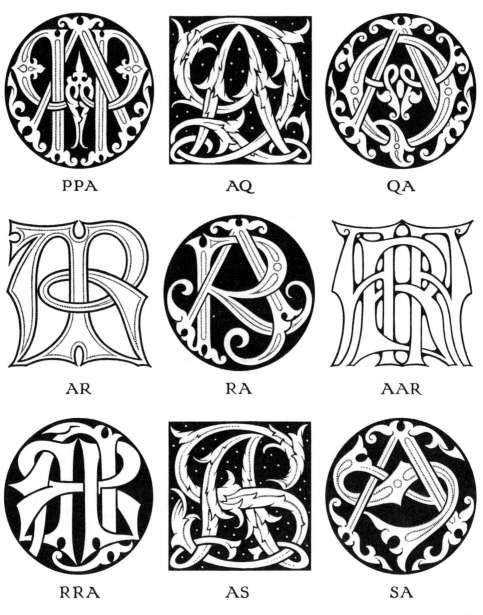

PPA AQ QA

AR RA AAR

RRA AS SA

6

PLATE IX—AP, AQ, AR, AS

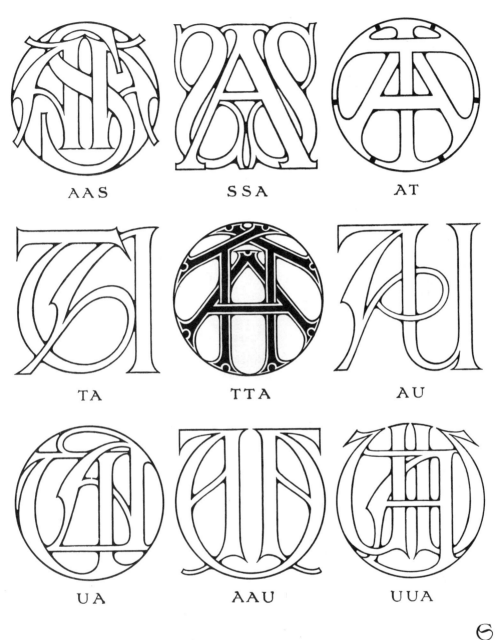

AAS SSA AT

TA TTA AU

UA AAU UUA

A·M·

𝔾

PLATE X—AS, AT, AU

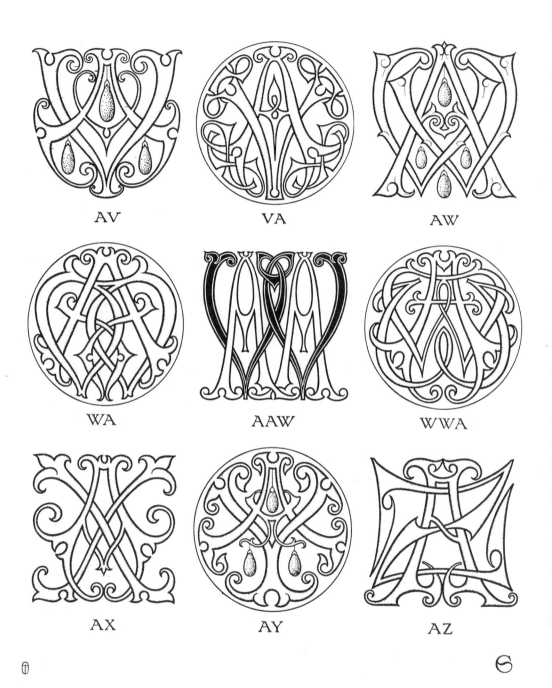

AV VA AW

WA AAW WWA

AX AY AZ

PLATE XI—AV, AW, AX, AY, AZ

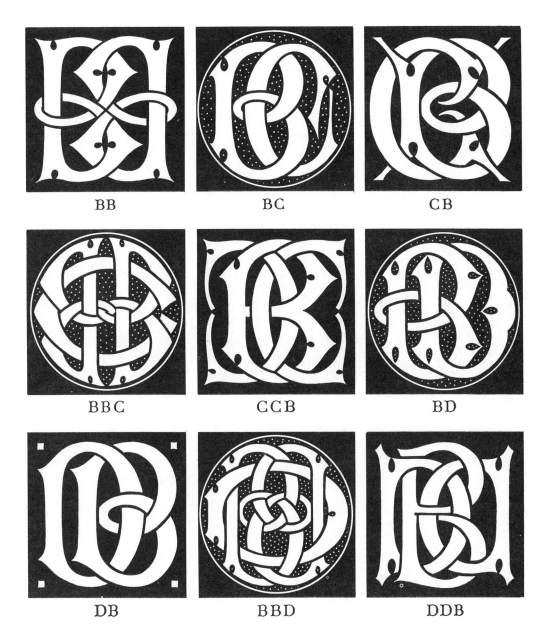

BB BC CB

BBC CCB BD

DB BBD DDB

PLATE XII—BB, BC, BD

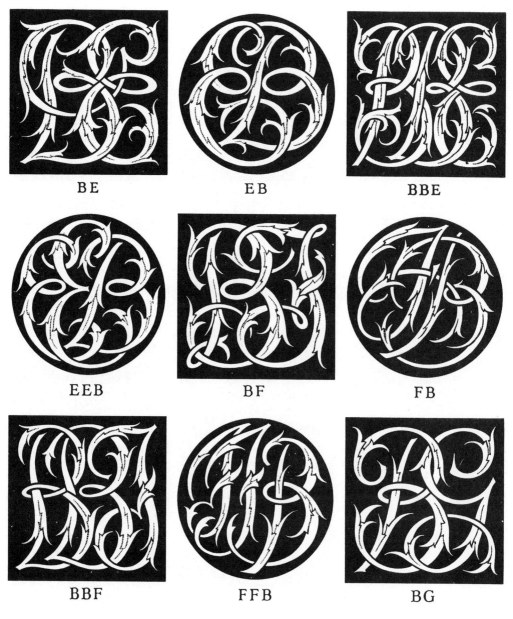

BE EB BBE

EEB BF FB

BBF FFB BG

6

PLATE XIII—BE, BF, BG

GB

BBG

GGB

BH

HB

BBH

HHB

BI

BBI

PLATE XIV—BG, BH, BI

IIB BJ JB

BK KB BBK

KKB BL LB

6

PLATE XV—BI, BJ, BK, BL

BBL LLB BM

MB BBM MMB

BN NB BBN

PLATE XVI—BL, BM, BN

NNB BO OB

BBO OOB BP

PB BBP PPB

PLATE XVII—BN, BO, BP

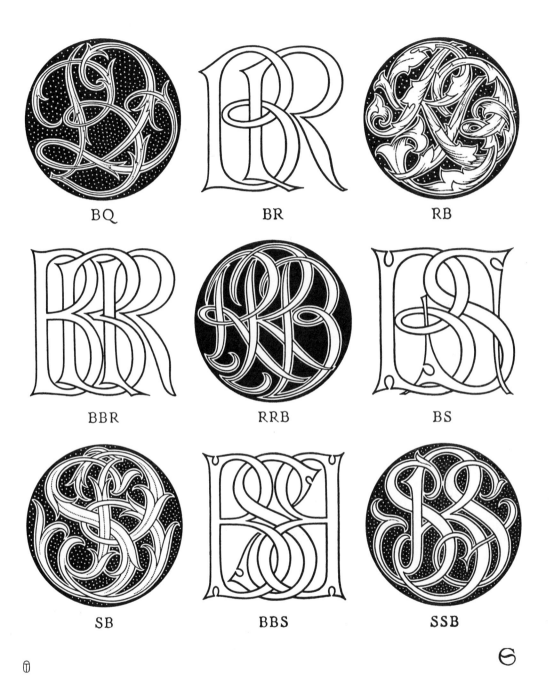

BQ

BR

RB

BBR

RRB

BS

SB

BBS

SSB

PLATE XVIII—BQ, BR, BS

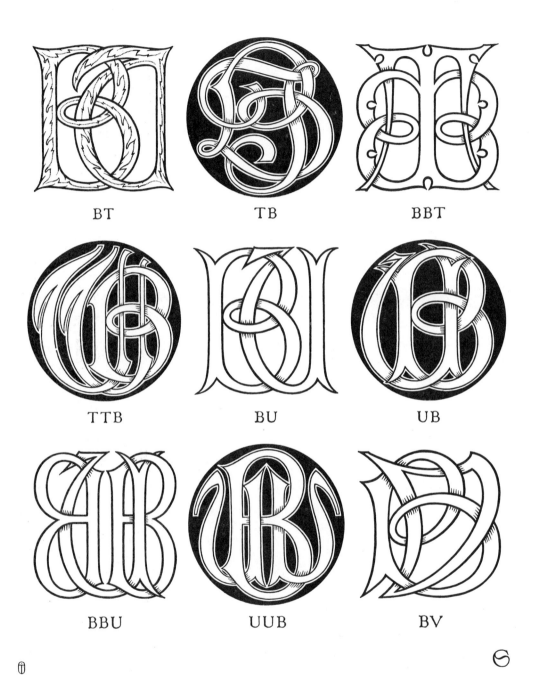

BT	TB	BBT
TTB	BU	UB
BBU	UUB	BV

PLATE XIX—BT, BU, BV

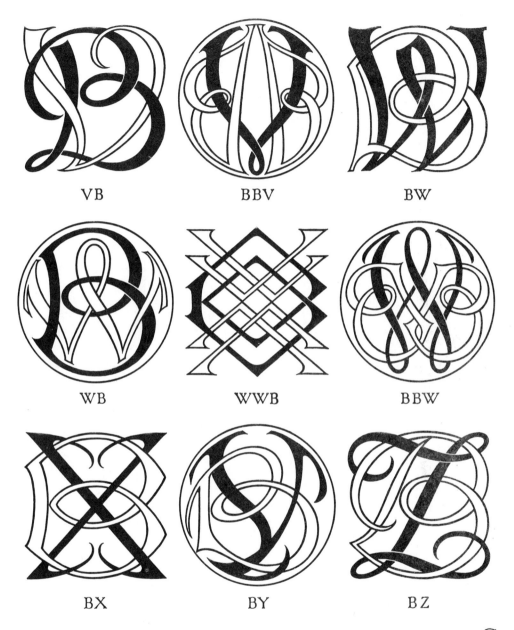

VB BBV BW

WB WWB BBW

BX BY BZ

PLATE XX—BV, BW, BX, BY, BZ

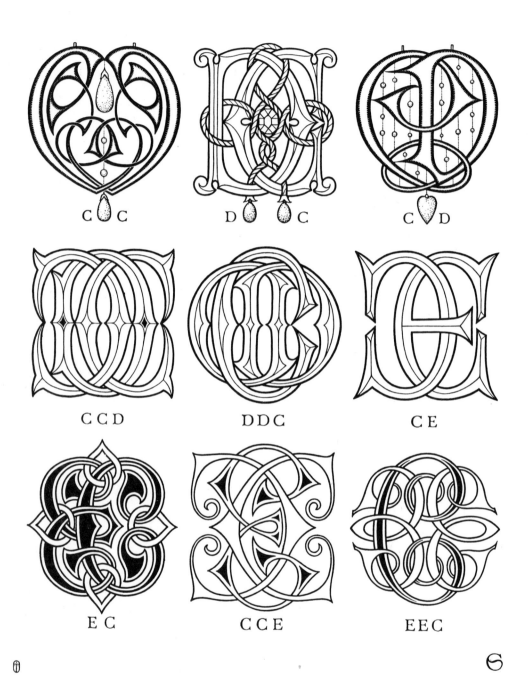

CC DC CD

CCD DDC CE

EC CCE EEC

PLATE XXI—CC, CD, CE

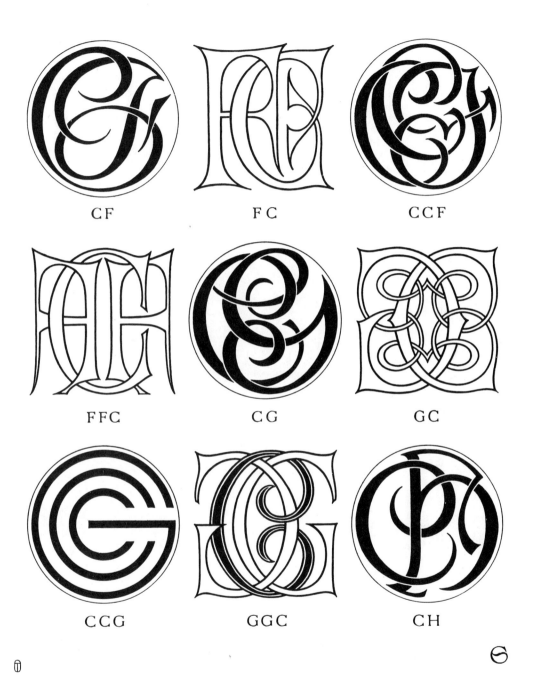

CF

FC

CCF

FFC

CG

GC

CCG

GGC

CH

PLATE XXII—CF, CG, CH

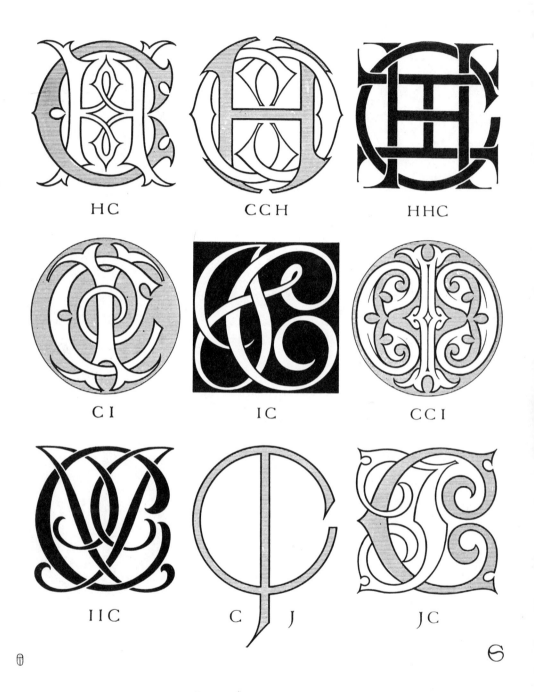

HC CCH HHC

CI IC CCI

IIC C J JC

PLATE XXIII—CH, CI, CJ

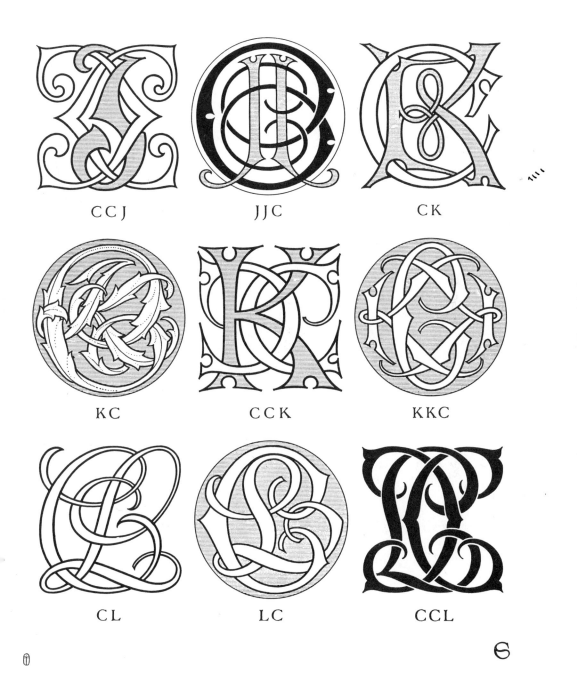

CCJ JJC CK

KC CCK KKC

CL LC CCL

PLATE XXIV—CJ, CK, CL

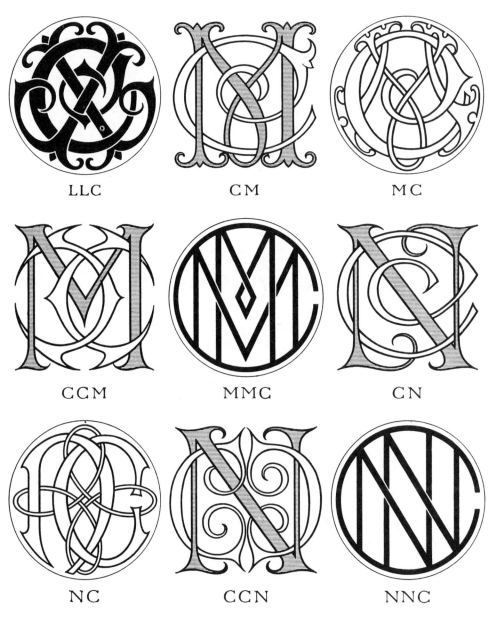

LLC CM MC

CCM MMC CN

NC CCN NNC

PLATE XXV—CL, CM, CN

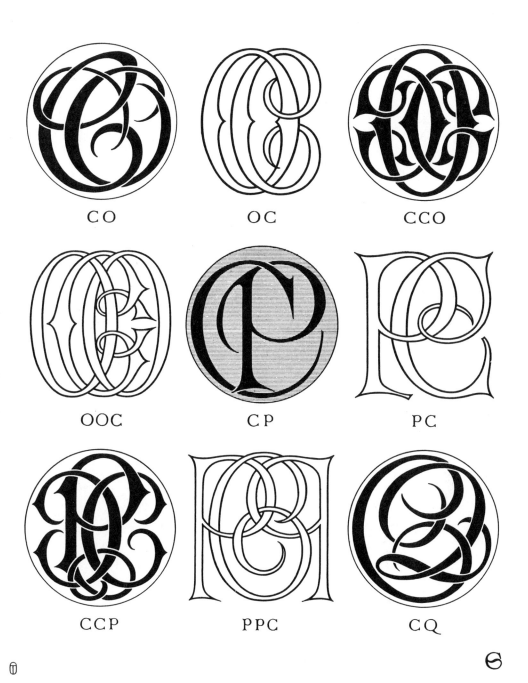

CO OC CCO

OOC CP PC

CCP PPC CQ

PLATE XXVI—CO, CP, CQ

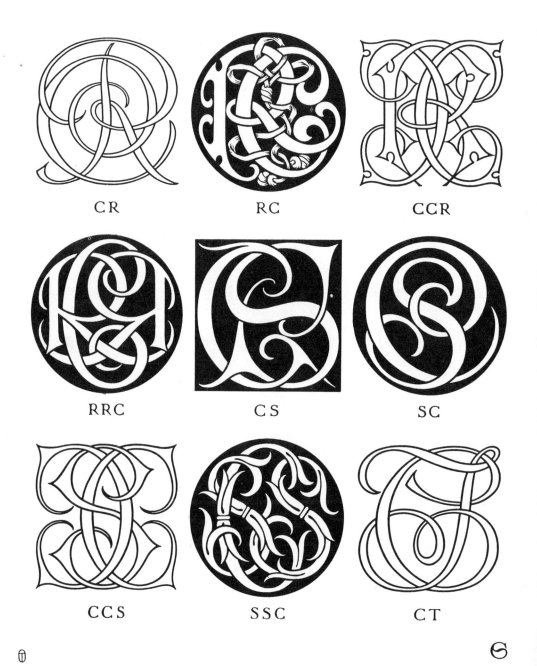

CR RC CCR

RRC CS SC

CCS SSC CT

PLATE XXVII—CR, CS, CT

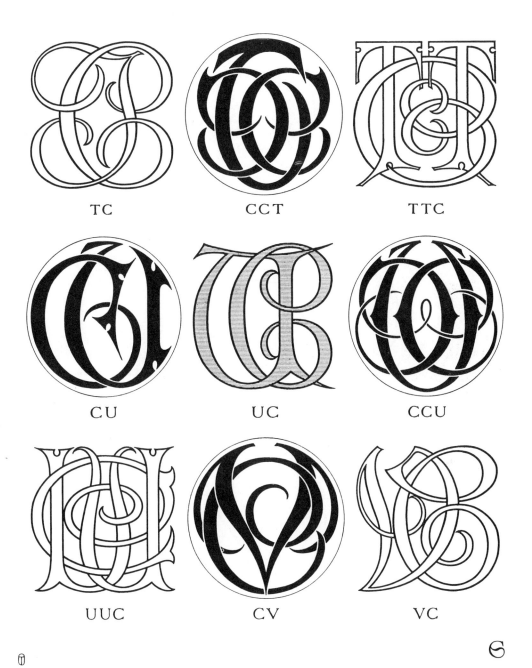

PLATE XXVIII—CT, CU, CV

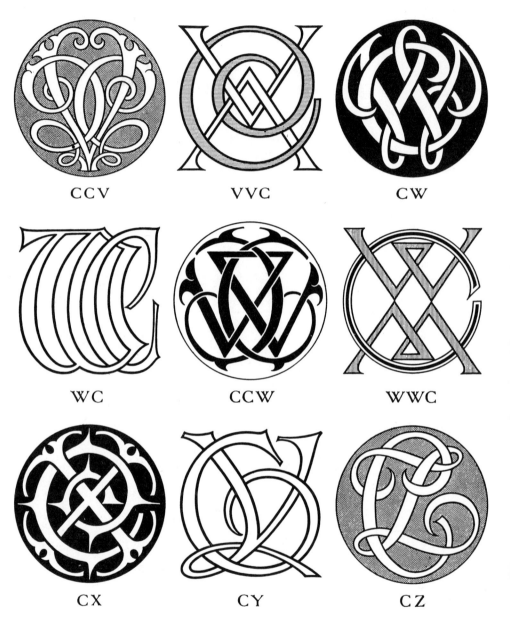

CCV VVC CW

WC CCW WWC

CX CY CZ

PLATE XXIX—CV, CW, CX, CY, CZ

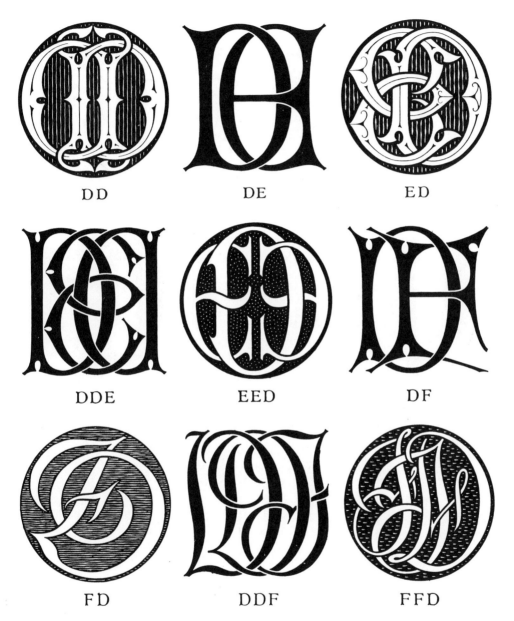

DD DE ED

DDE EED DF

FD DDF FFD

PLATE XXX—DD, DE, DF

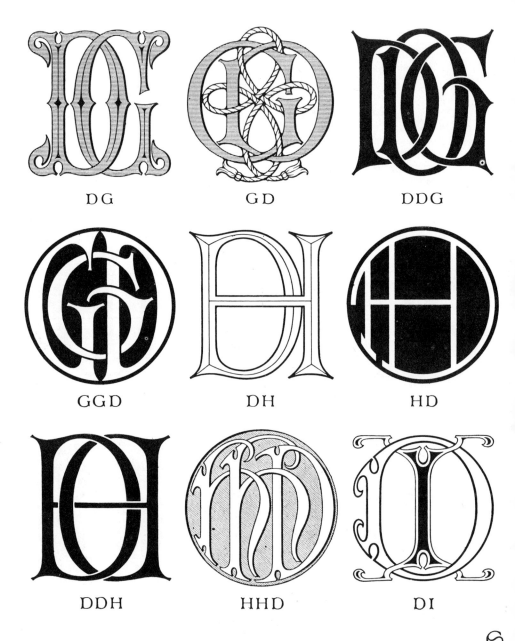

DG GD DDG

GGD DH HD

DDH HHD DI

PLATE XXXI—DG, DH, DI

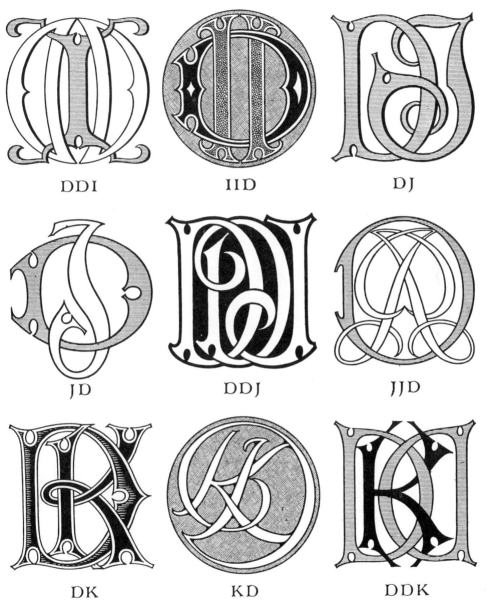

DDI IID DJ

JD DDJ JJD

DK KD DDK

PLATE XXXII—DI, DJ, DK

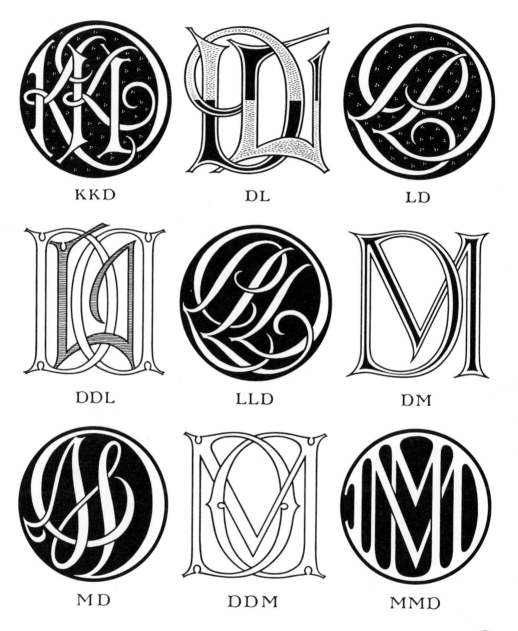

KKD DL LD

DDL LLD DM

MD DDM MMD

PLATE XXXIII—DK, DL, DM

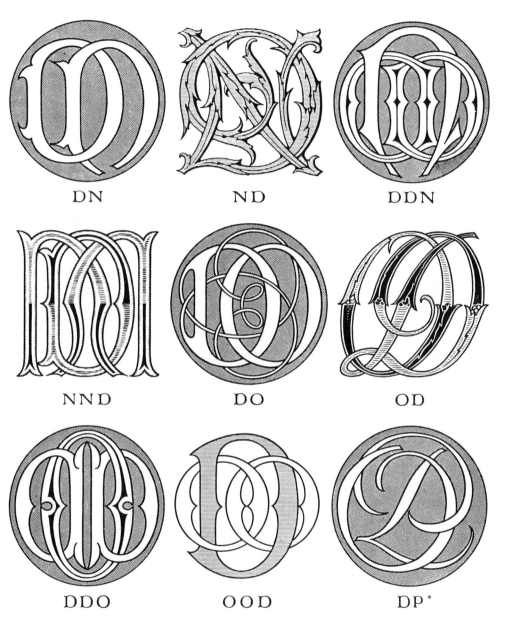

DN ND DDN

NND DO OD

DDO OOD DP*

* This cipher is OP not DP. See page xxi.

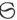

PLATE XXXIV—DN, DO, DP

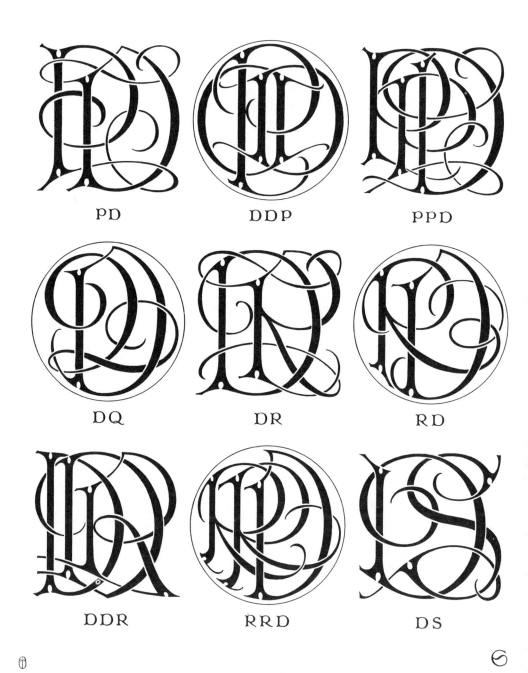

PD DDP PPD

DQ DR RD

DDR RRD DS

PLATE XXXV—DP, DQ, DR, DS

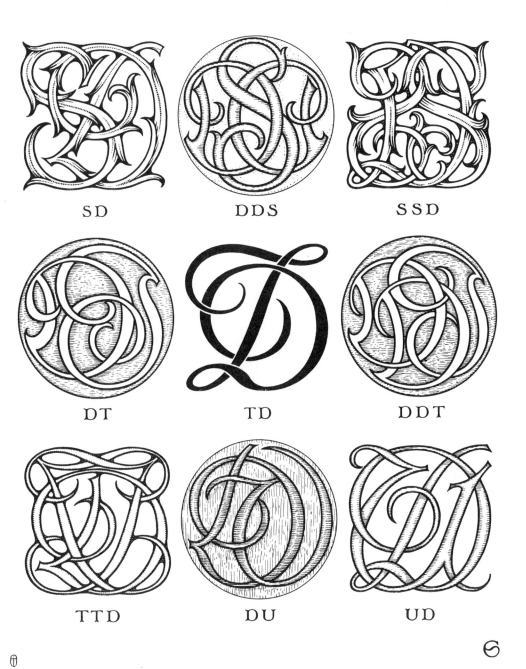

SD DDS SSD

DT TD DDT

TTD DU UD

PLATE XXXVI—DS, DT, DU

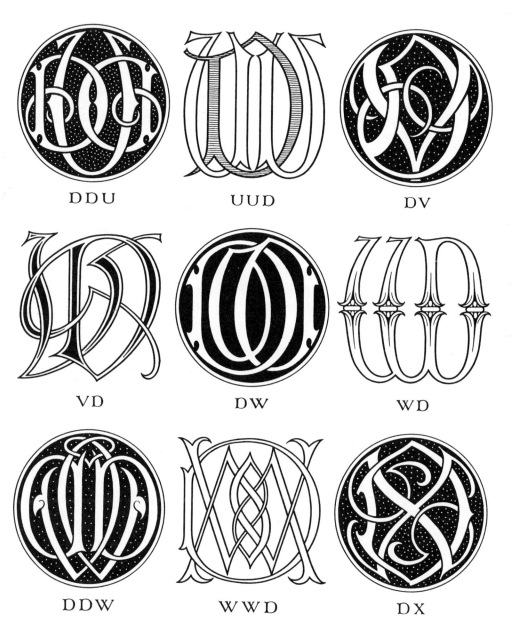

DDU UUD DV

VD DW WD

DDW WWD DX

PLATE XXXVII—DU, DV, DW, DX

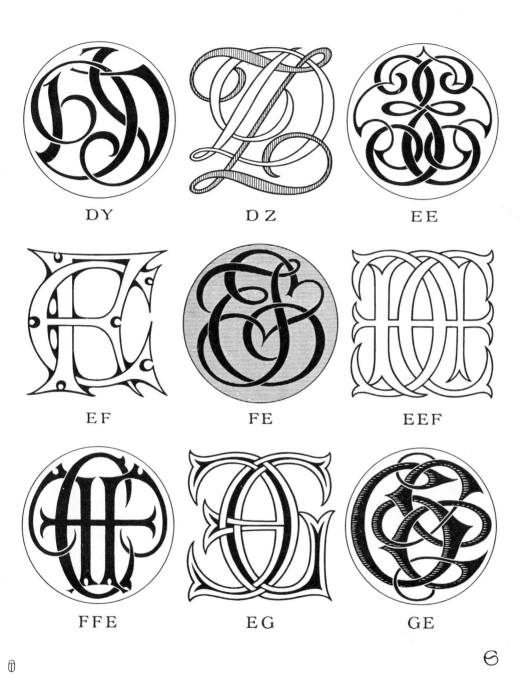

DY D Z EE

EF FE EEF

FFE EG GE

PLATE XXXVIII—DY, DZ, EE, EF, EG

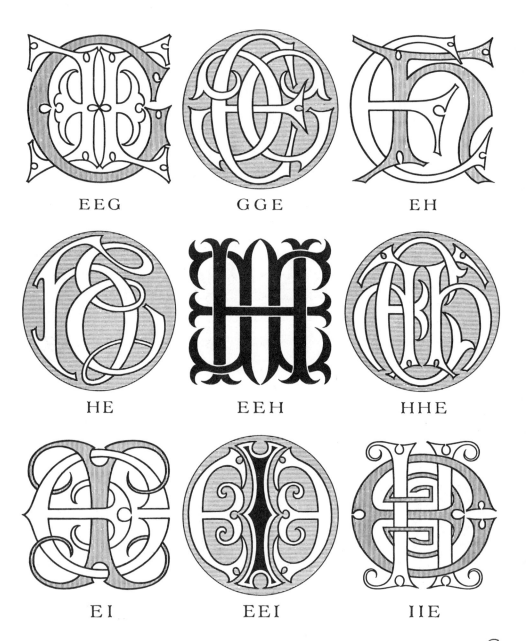

EEG GGE EH

HE EEH HHE

EI EEI IIE

PLATE XXXIX—EG, EH, EI

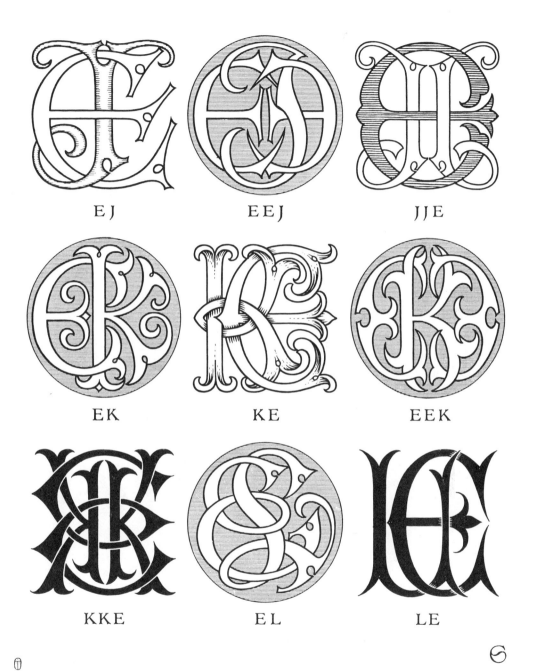

EJ EEJ JJE

EK KE EEK

KKE EL LE

PLATE XL—EJ, EK, EL

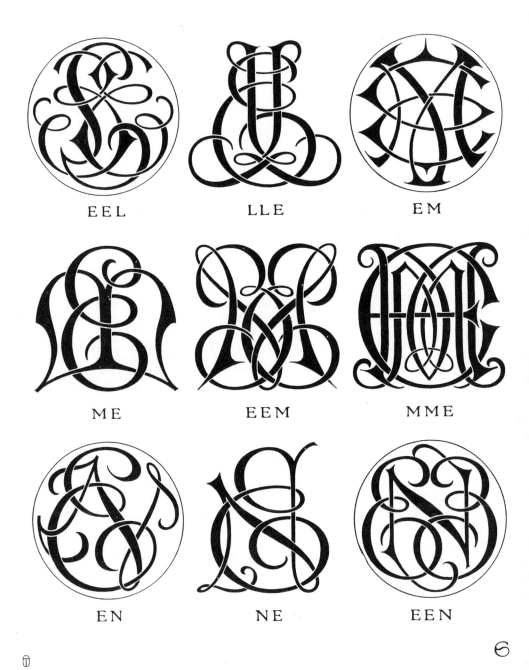

EEL LLE EM

ME EEM MME

EN NE EEN

PLATE XLI—EL, EM, EN

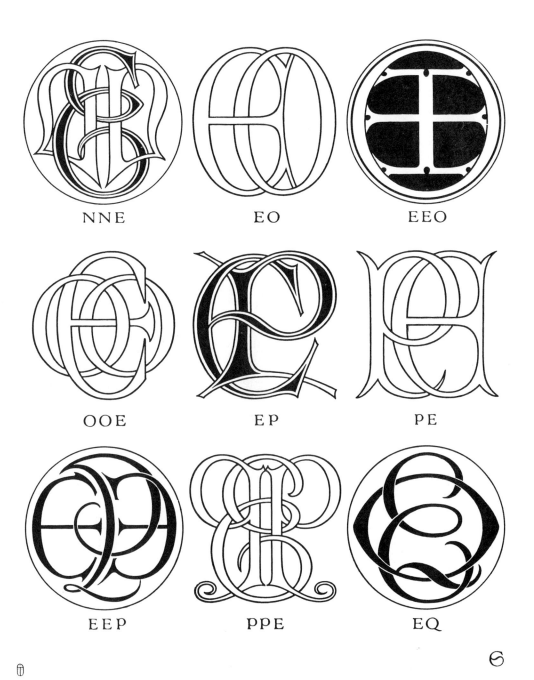

NNE EO EEO

OOE EP PE

EEP PPE EQ

PLATE XLII—EN, EO, EP, EQ

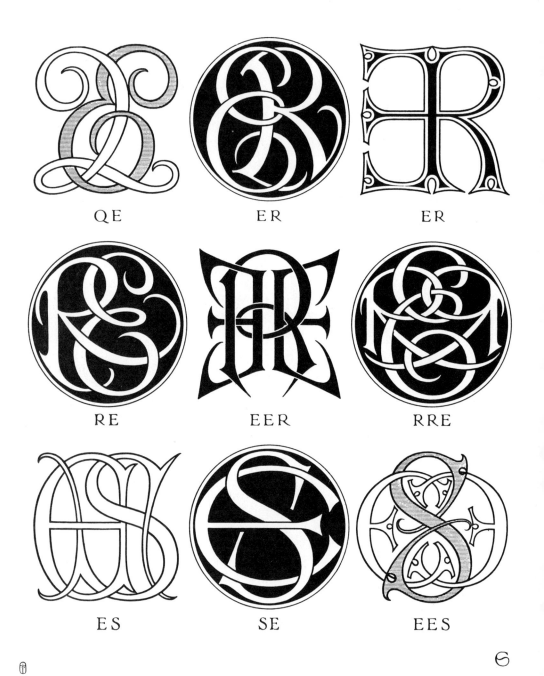

QE ER ER

RE EER RRE

ES SE EES

PLATE XLIII—EQ, ER, ES

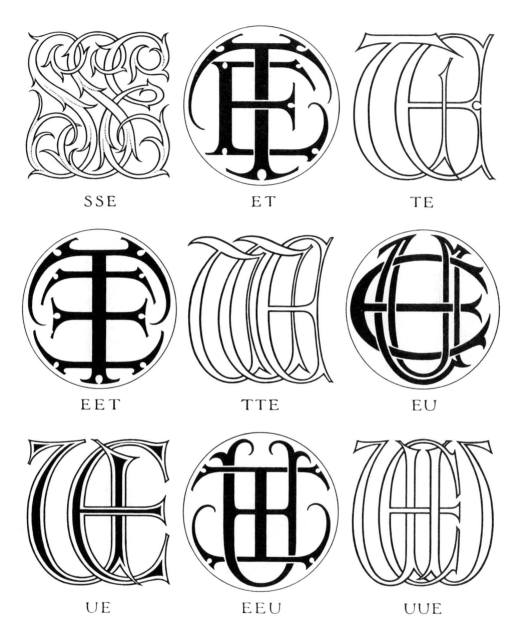

SSE ET TE

EET TTE EU

UE EEU UUE

PLATE XLIV—ES, ET, EU

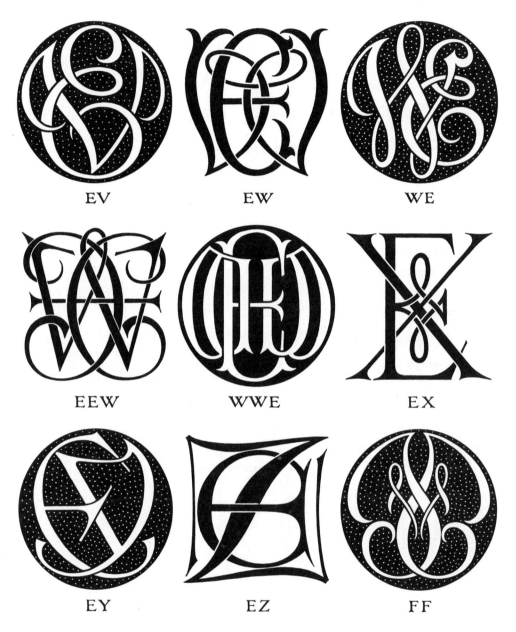

EV EW WE

EEW WWE EX

EY EZ FF

PLATE XLV—EV, EW, EX, EY, EZ, FF

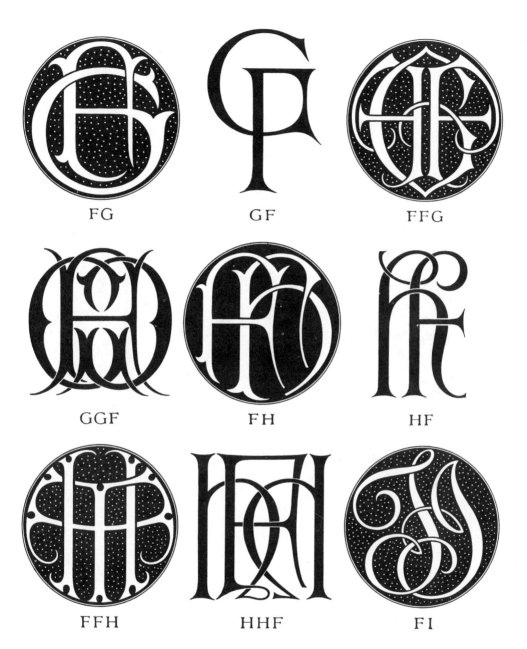

FG GF FFG

GGF FH HF

FFH HHF FI

PLATE XLVI—FG, FH, FI

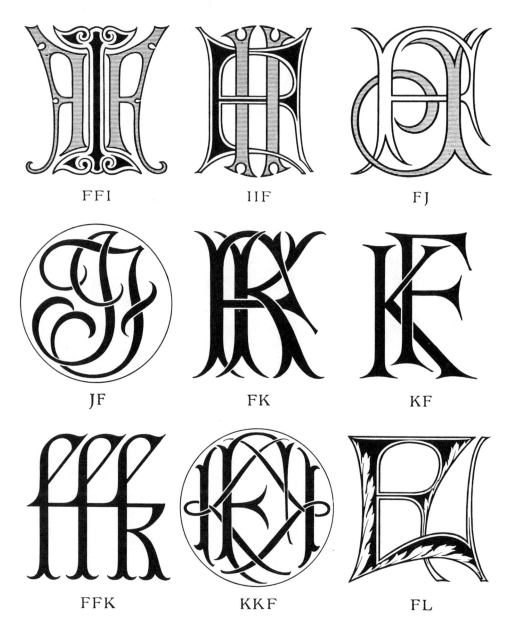

FFI IIF FJ

JF FK KF

FFK KKF FL

PLATE XLVII—FI, FJ, FK, FL

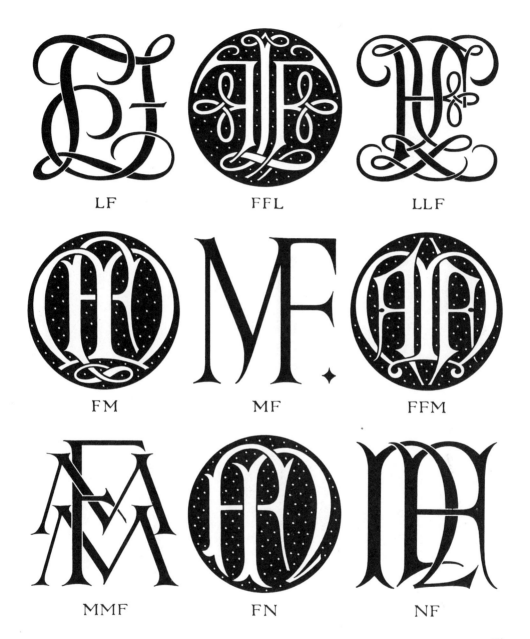

LF FFL LLF

FM MF FFM

MMF FN NF

PLATE XLVIII—FL, FM, FN

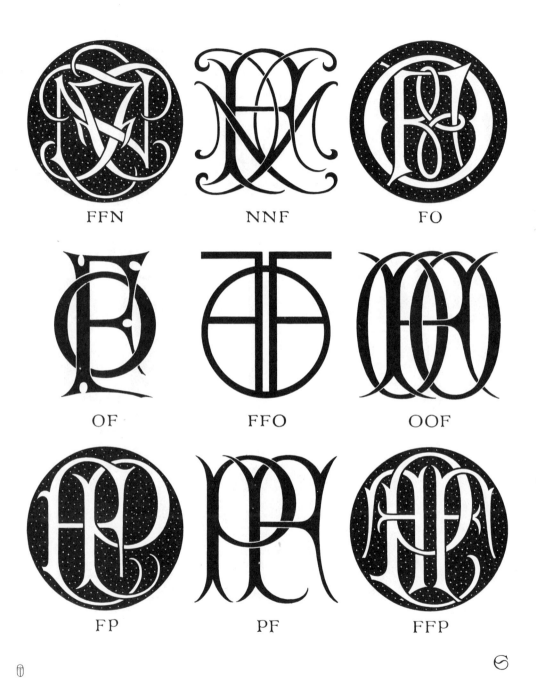

FFN NNF FO

OF FFO OOF

FP PF FFP

PLATE XLIX—FN, FO, FP

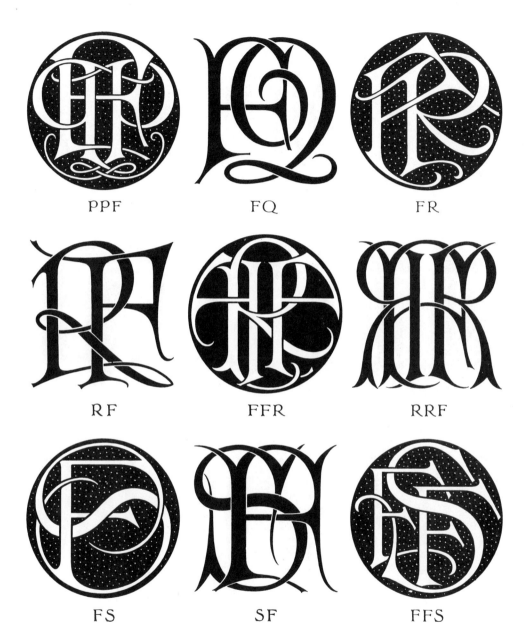

PPF FQ FR

RF FFR RRF

FS SF FFS

PLATE L—FP, FQ, FR, FS

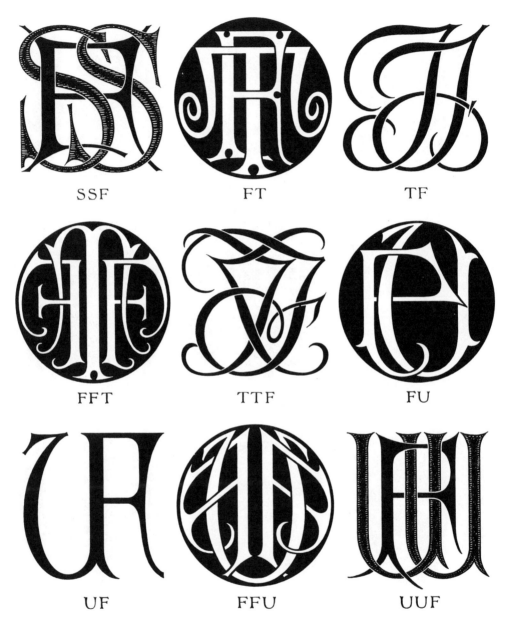

SSF FT TF

FFT TTF FU

UF FFU UUF

PLATE LI—FS, FT, FU

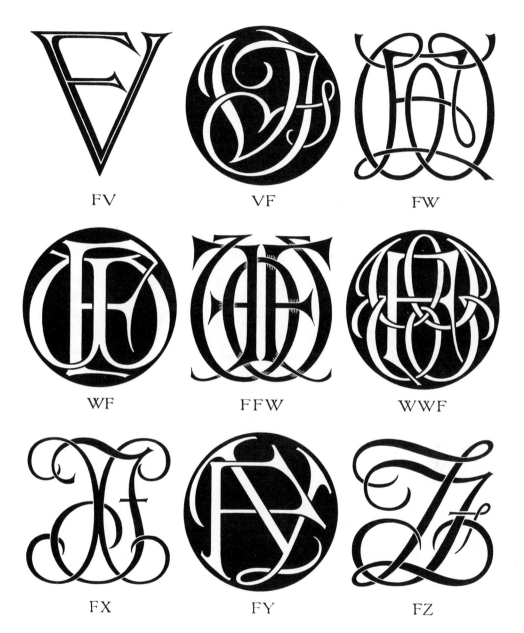

FV VF FW

WF FFW WWF

FX FY FZ

PLATE LII—FV, FW, FX, FY, FZ

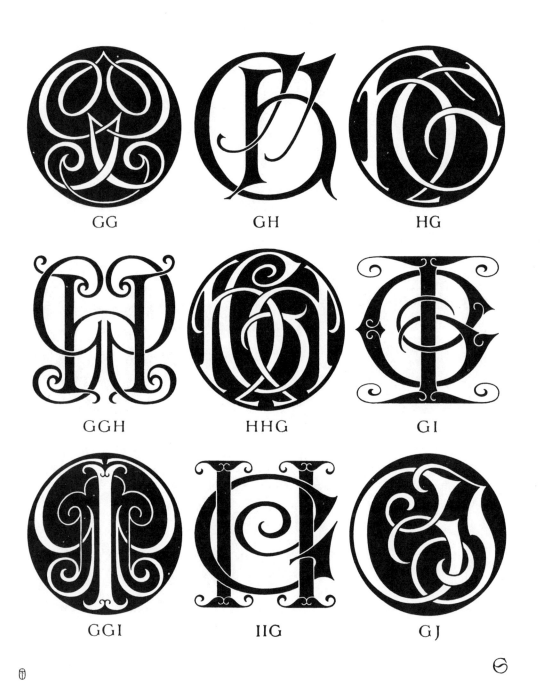

GG GH HG

GGH HHG GI

GGI IIG GJ

PLATE LIII—GG, GH, GI, GJ

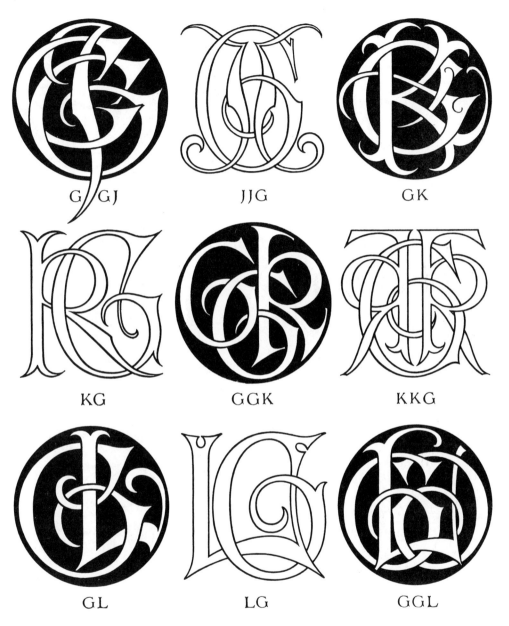

G GJ

JJG

GK

KG

GGK

KKG

GL

LG

GGL

PLATE LIV—GJ, GK, GL

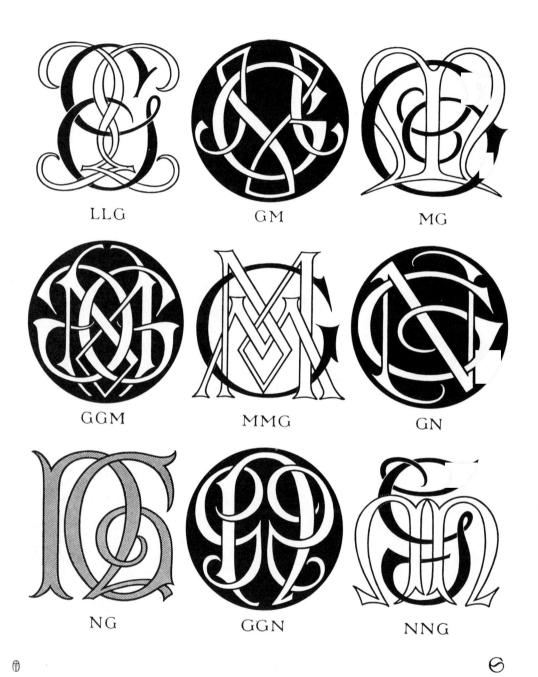

LLG GM MG

GGM MMG GN

NG GGN NNG

PLATE LV—GL, GM, GN

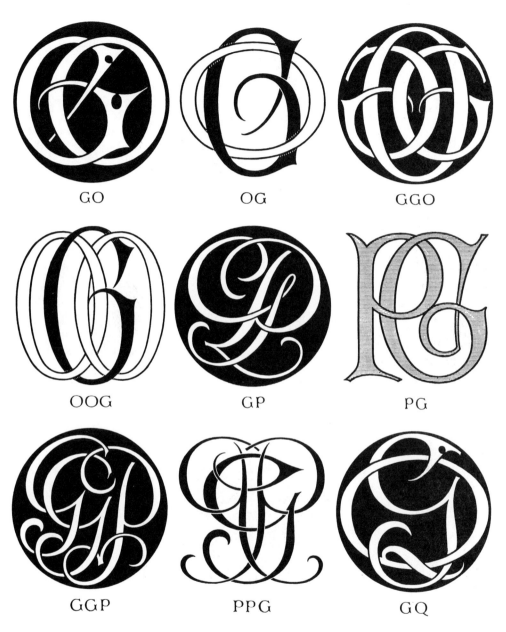

GO OG GGO

OOG GP PG

GGP PPG GQ

PLATE LVI—GO, GP, GQ

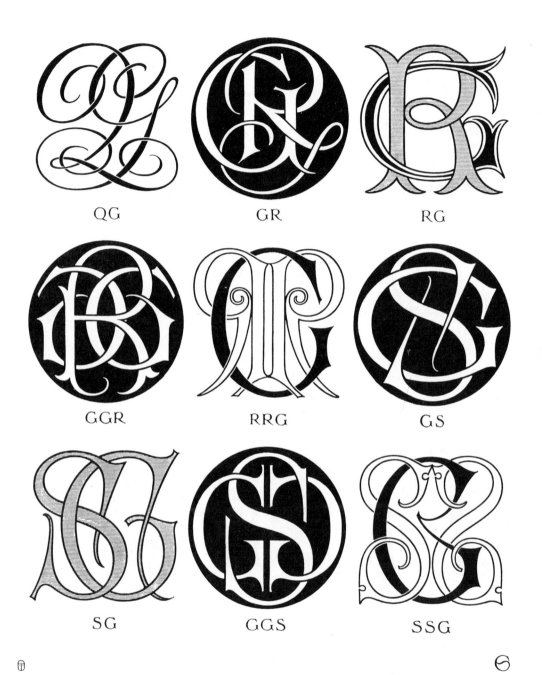

QG GR RG

GGR RRG GS

SG GGS SSG

PLATE LVII—GQ, GR, GS

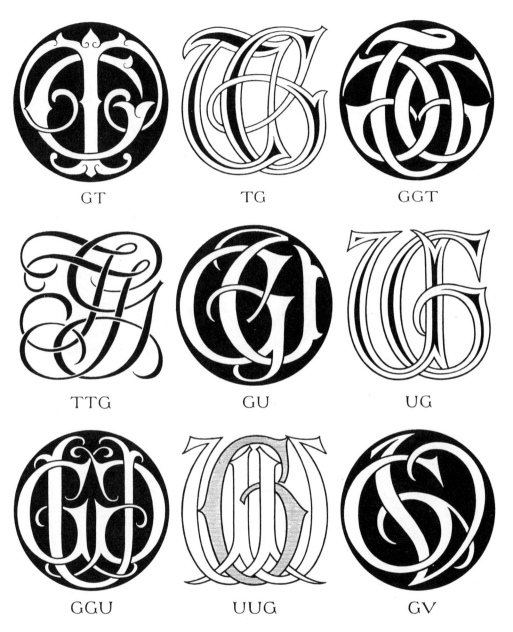

GT TG GGT

TTG GU UG

GGU UUG GV

PLATE LVIII—GT, GU, GV

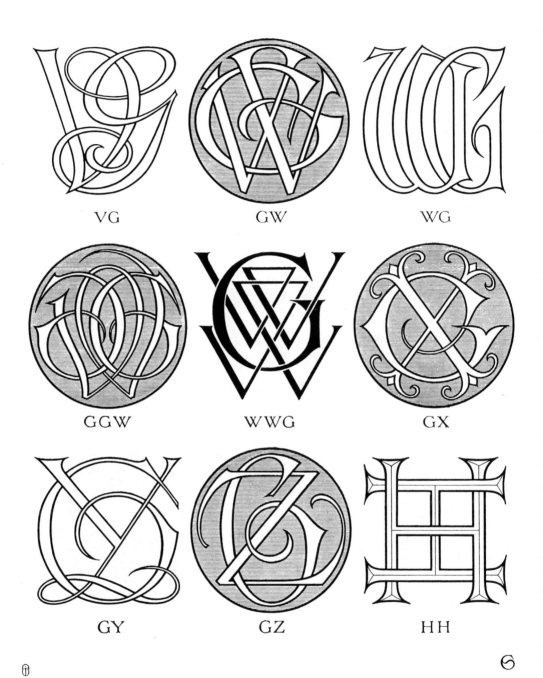

VG GW WG

GGW WWG GX

GY GZ HH

PLATE LIX—GV, GW, GX, GY, GZ, HH

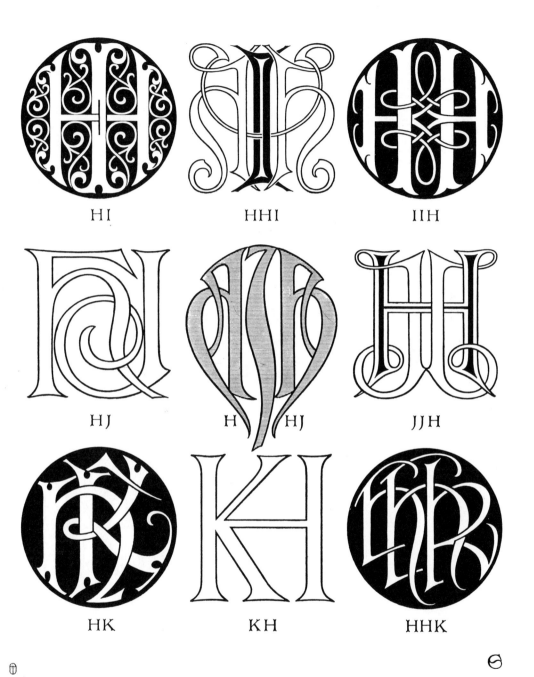

HI HHI IIH

HJ H HJ JJH

HK KH HHK

PLATE LX—III, HJ, HK

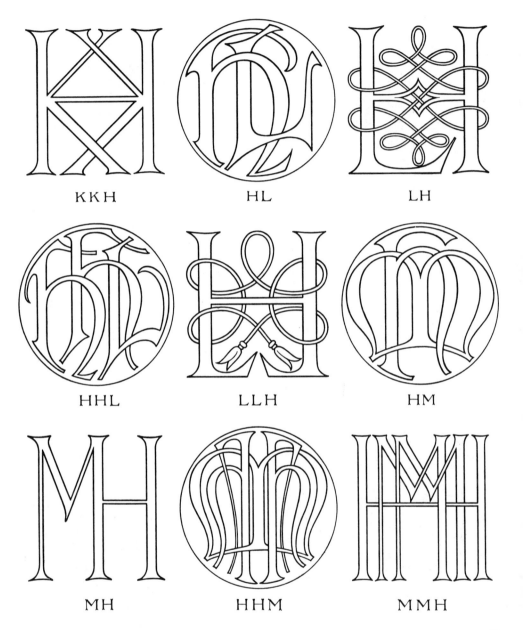

KKH HL LH

HHL LLH HM

MH HHM MMH

PLATE LXI—HK, HL, HM

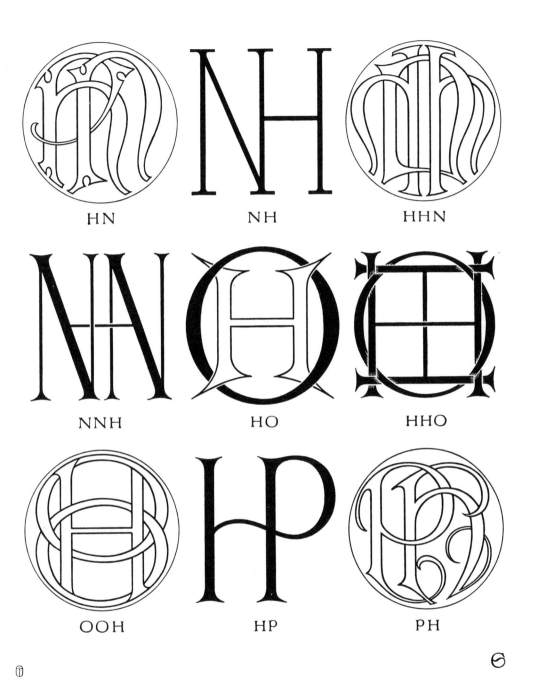

HN NH HHN

NNH HO HHO

OOH HP PH

PLATE LXII—IIN, HO, HP

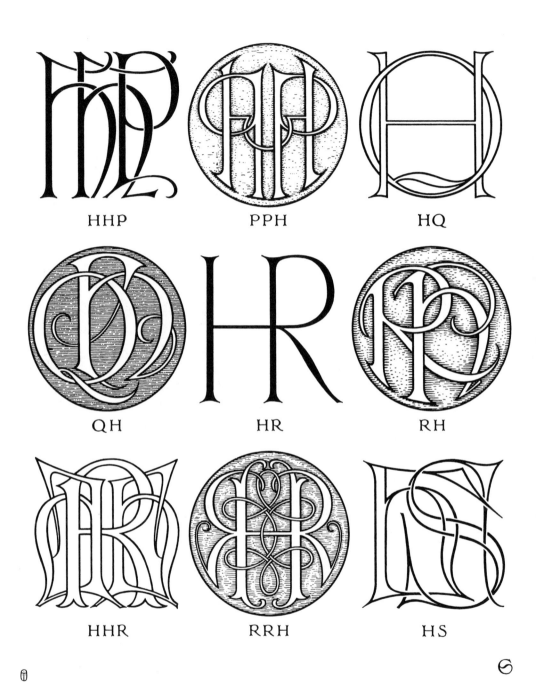

HHP PPH HQ

QH HR RH

HHR RRH HS

PLATE LXIII—HP, HQ, HR, HS

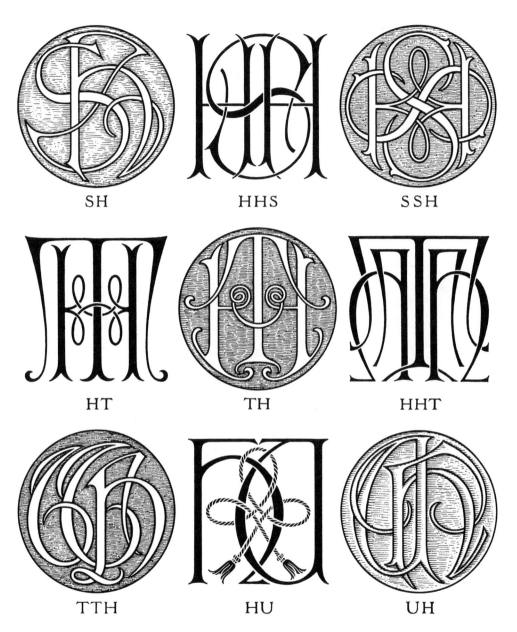

SH HHS SSH

HT TH HHT

TTH HU UH

PLATE LXIV—HS, HT, HU

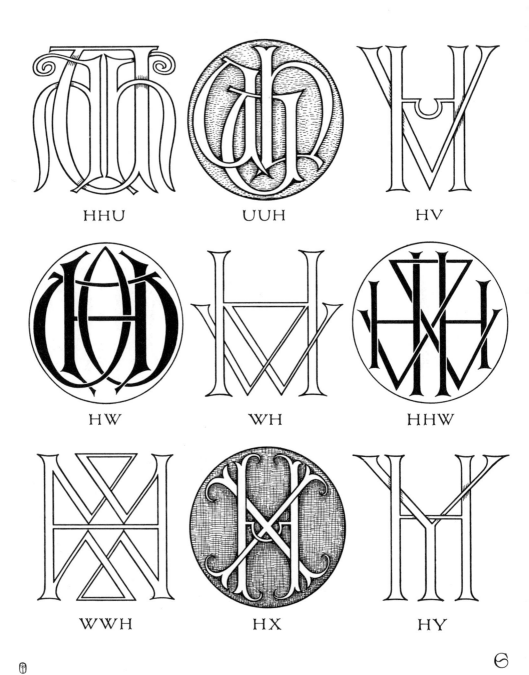

HHU UUH HV

HW WH HHW

WWH HX HY

PLATE LXV—HU, HV, HW, HX, HY

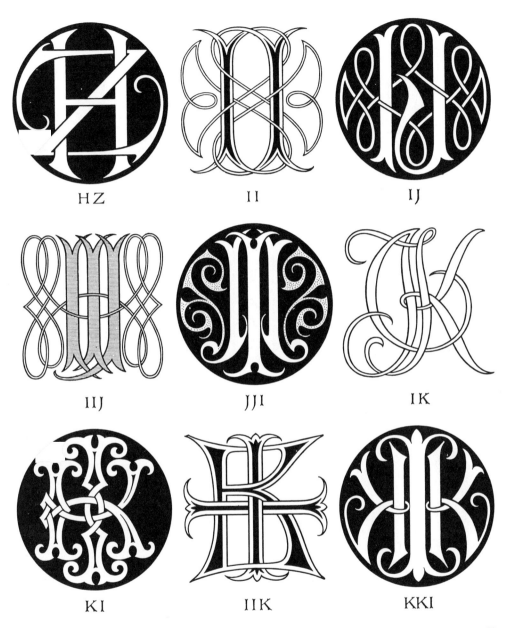

HZ II IJ

IIJ JJI IK

KI IIK KKI

PLATE LXVI—HZ, II, IJ, IK

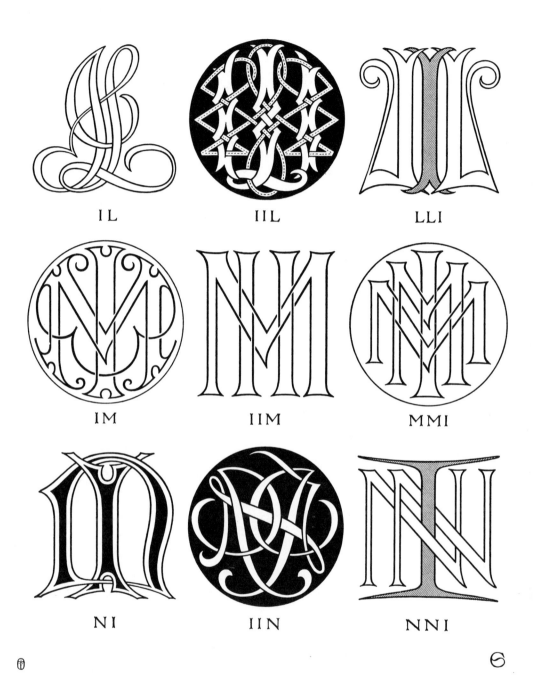

IL IIL LLI

IM IIM MMI

NI IIN NNI

PLATE LXVII—IL, IM, IN

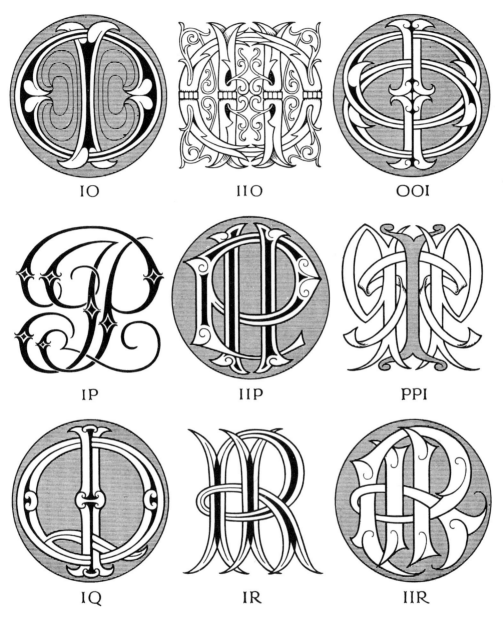

IO IIO OOI

IP IIP PPI

IQ IR IIR

PLATE LXVIII—IO, IP, IQ, IR

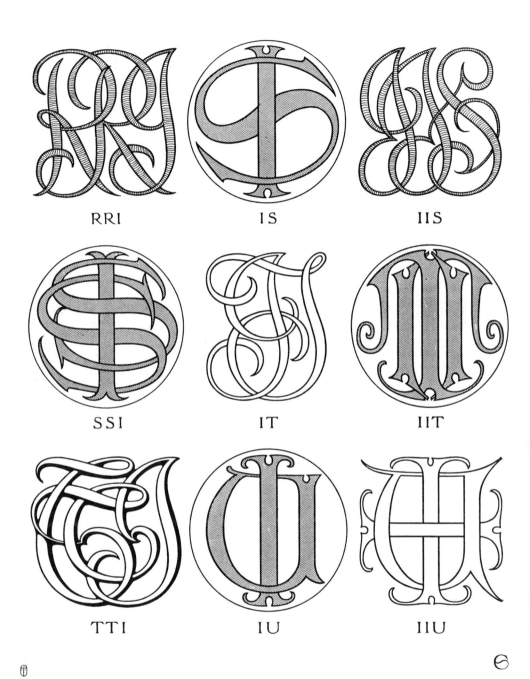

RRI IS IIS

SSI IT IIT

TTI IU IIU

PLATE LXIX—IR, IS, IT, IU

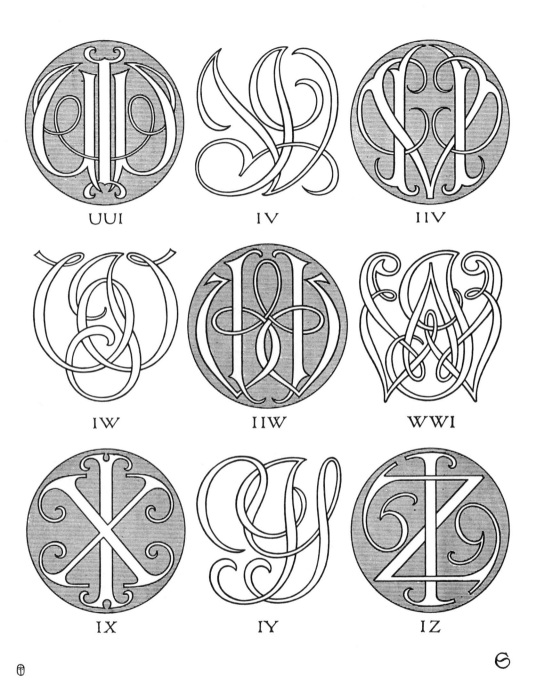

UUI IV IIV

IW IIW WWI

IX IY IZ

PLATE LXX—IU, IV, IW, IX, IY, IZ

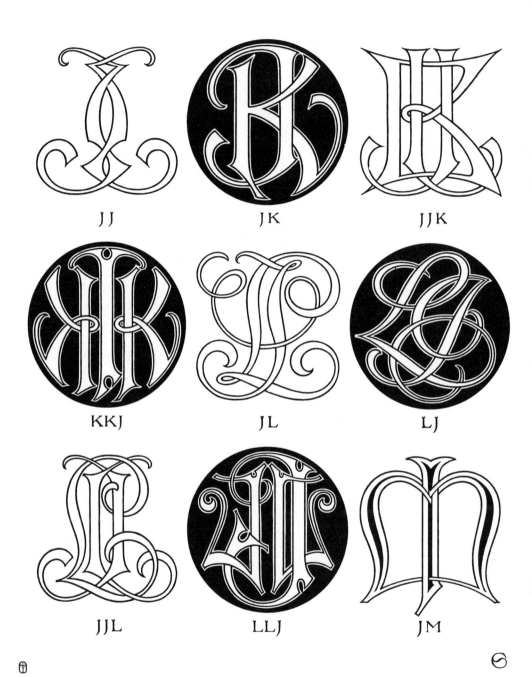

JJ

JK

JJK

KKJ

JL

LJ

JJL

LLJ

JM

PLATE LXXI—JJ, JK, JL, JM

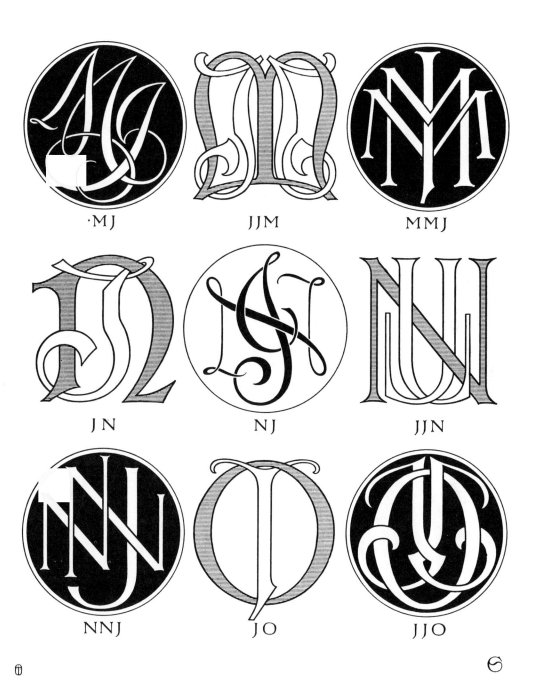

·MJ

JJM

MMJ

JN

NJ

JJN

NNJ

JO

JJO

PLATE LXXII—JM, JN, JO

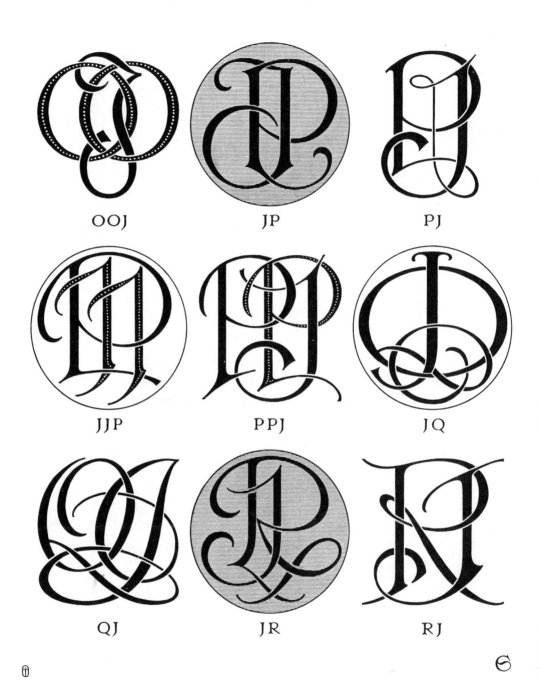

OOJ JP PJ

JJP PPJ JQ

QJ JR RJ

PLATE LXXIII—JO, JP, JQ, JR

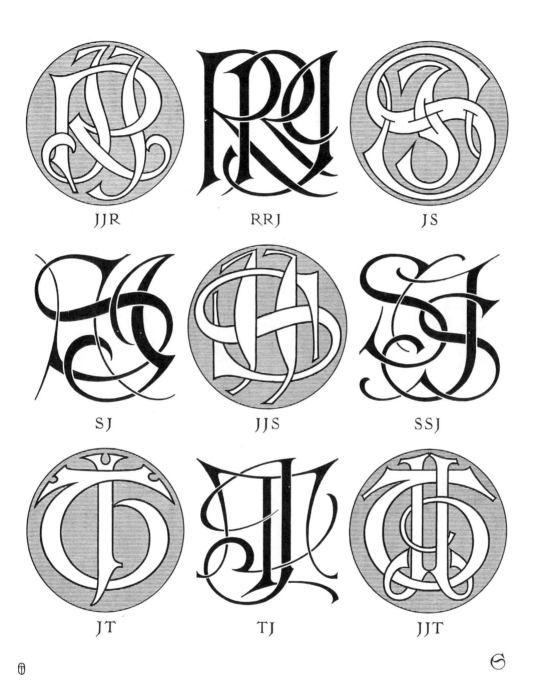

JJR RRJ JS

SJ JJS SSJ

JT TJ JJT

PLATE LXXIV—JR, JS, JT

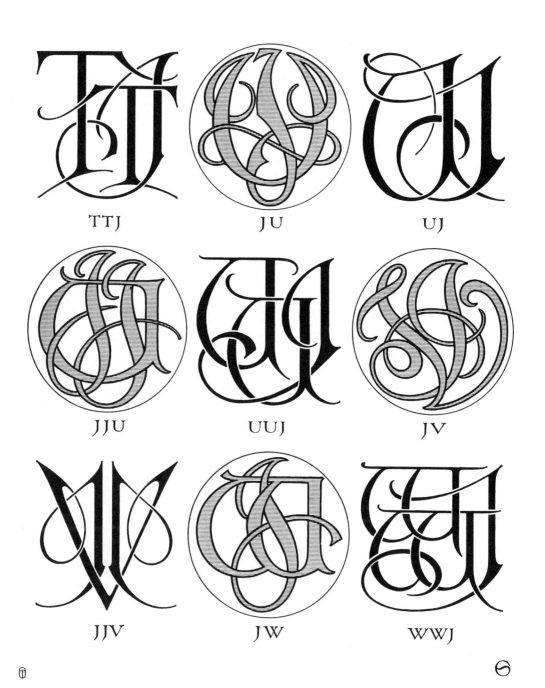

TTJ

JU

UJ

JJU

UUJ

JV

JJV

JW

WWJ

PLATE LXXV—JT, JU, JV, JW

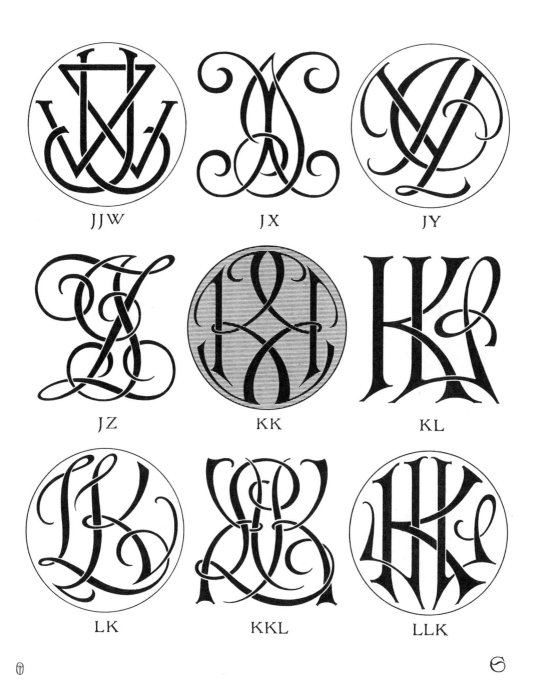

JJW JX JY

JZ KK KL

LK KKL LLK

PLATE LXXVI—JW, JX, JY, JZ, KK, KL

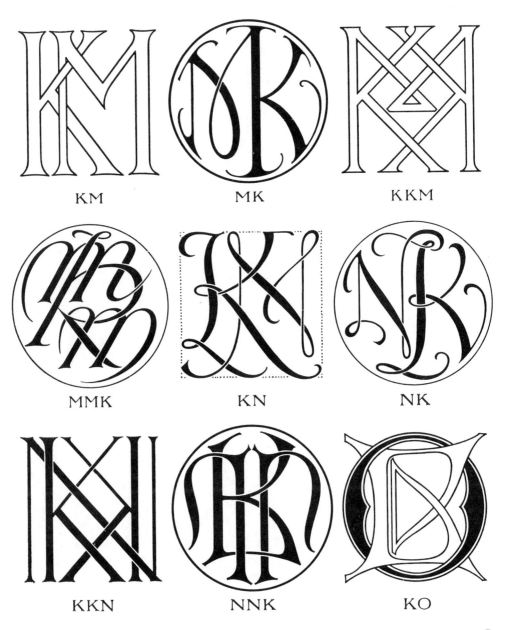

KM MK KKM

MMK KN NK

KKN NNK KO

PLATE LXXVII—KM, KN, KO

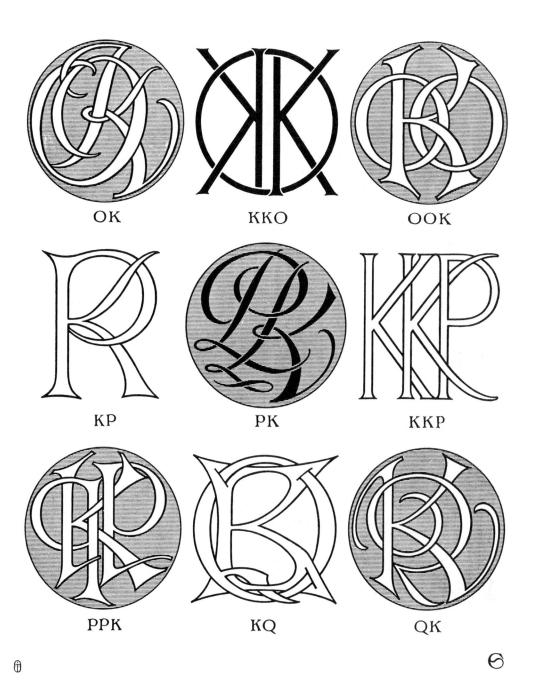

OK

KKO

OOK

KP

PK

KKP

PPK

KQ

QK

PLATE LXXVIII—KO, KP, KQ

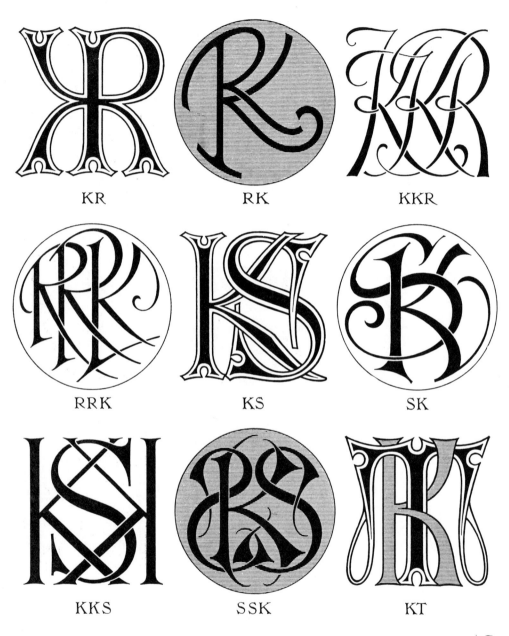

KR RK KKR

RRK KS SK

KKS SSK KT

PLATE LXXIX—KR, KS, KT

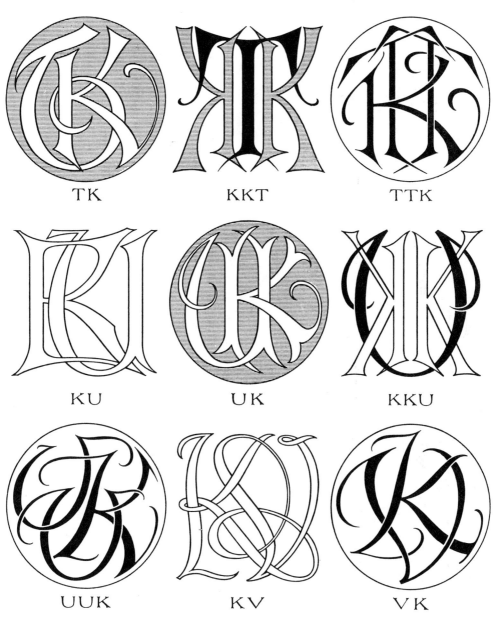

TK KKT TTK

KU UK KKU

UUK KV VK

PLATE LXXX—KT, KU, KV

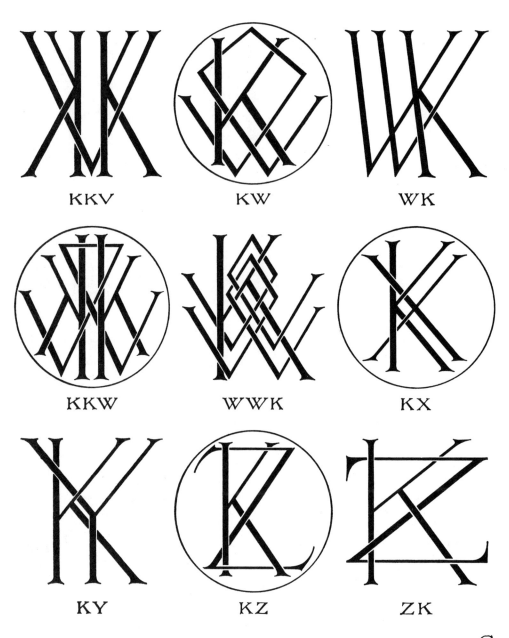

KKV KW WK

KKW WWK KX

KY KZ ZK

PLATE LXXXI—KV, KW, KX, KY, KZ

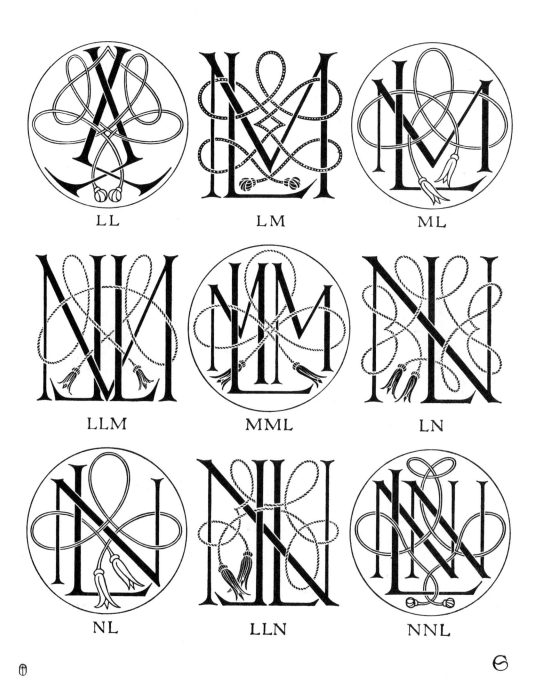

LL LM ML

LLM MML LN

NL LLN NNL

PLATE LXXXII—LL, LM, LN

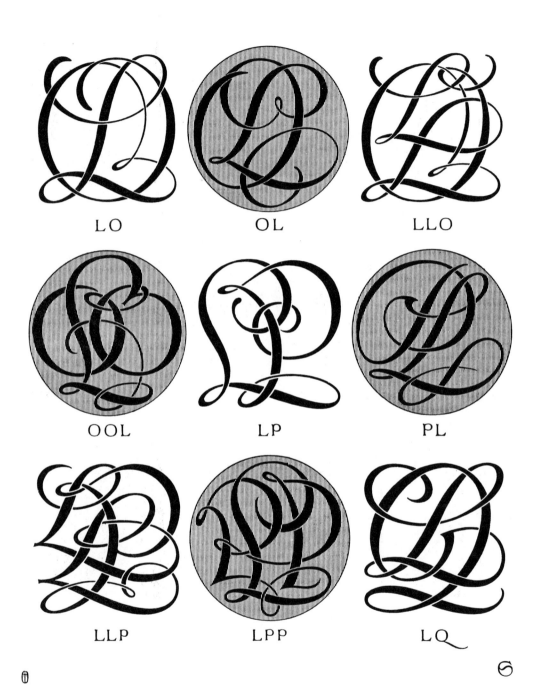

LO OL LLO

OOL LP PL

LLP LPP LQ

PLATE LXXXIII—LO, LP, LQ

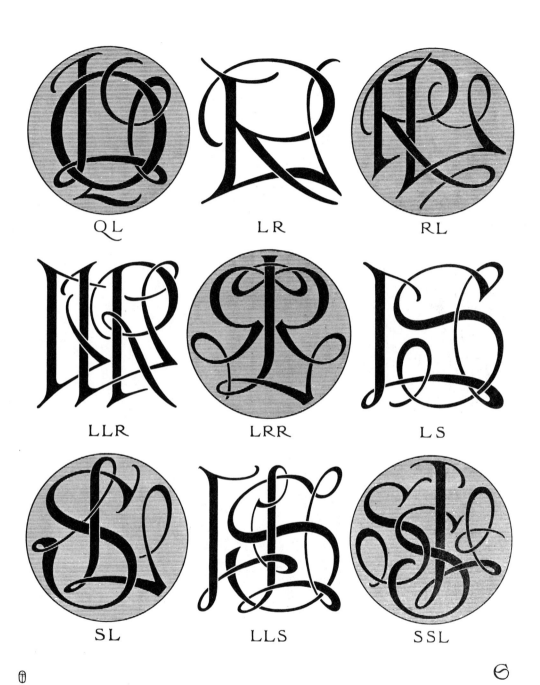

QL LR RL

LLR LRR LS

SL LLS SSL

PLATE LXXXIV—LQ, LR, LS

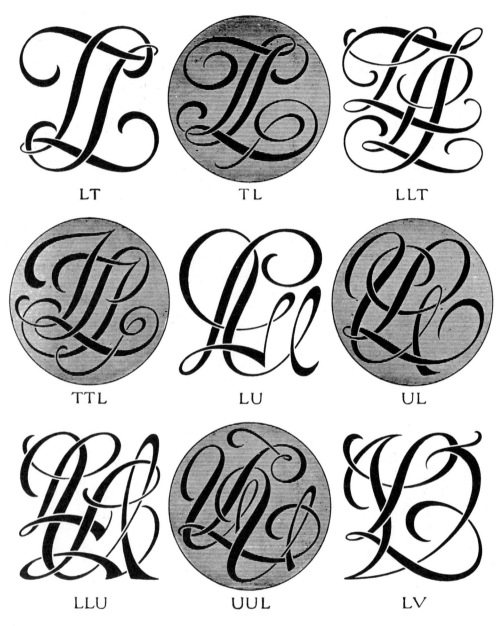

LT TL LLT

TTL LU UL

LLU UUL LV

PLATE LXXXV—LT, LU, LV

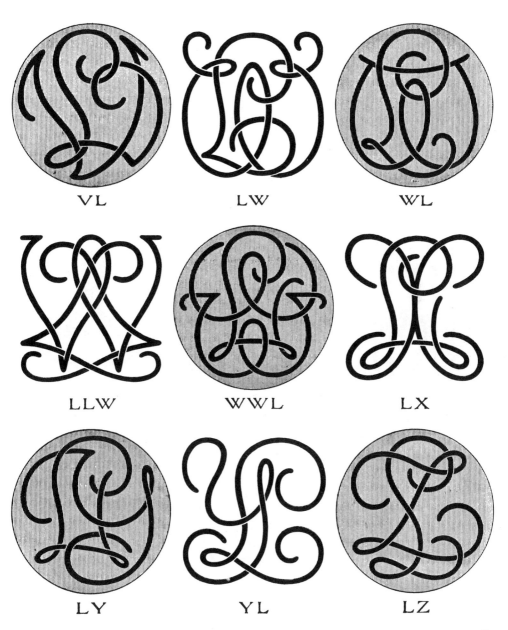

VL LW WL

LLW WWL LX

LY YL LZ

PLATE LXXXVI—LV, LW, LX, LY, LZ

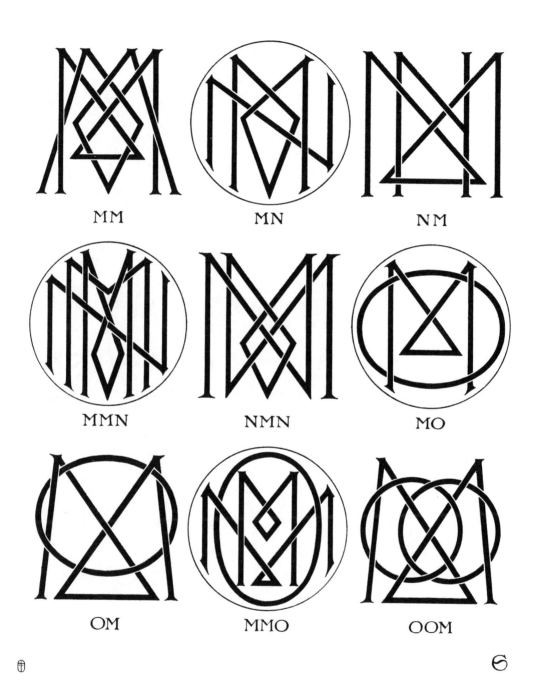

MM MN NM

MMN NMN MO

OM MMO OOM

PLATE LXXXVII—MM, MN, MO

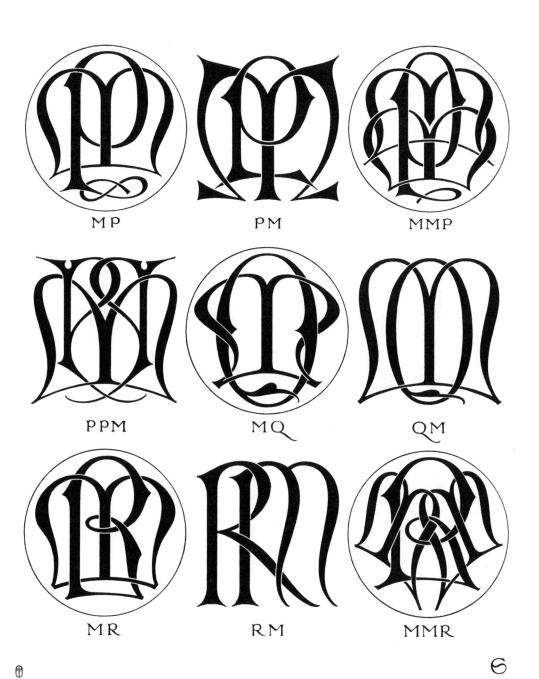

MP PM MMP

PPM MQ QM

MR RM MMR

PLATE LXXXVIII—MP, MQ, MR

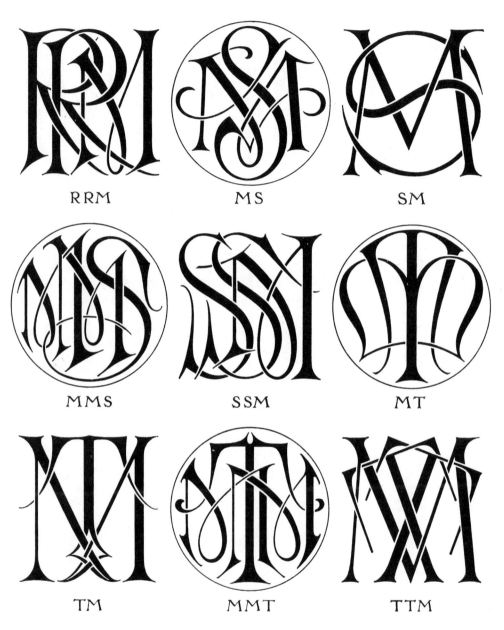

RRM MS SM

MMS SSM MT

TM MMT TTM

PLATE LXXXIX—MR, MS, MT

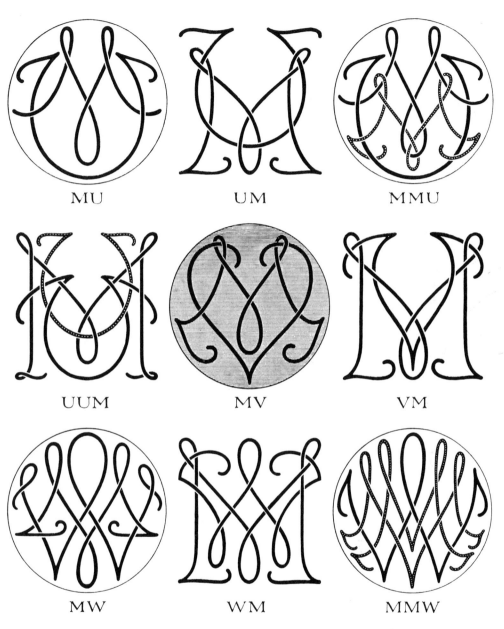

MU UM MMU

UUM MV VM

MW WM MMW

PLATE XC—MU, MV, MW

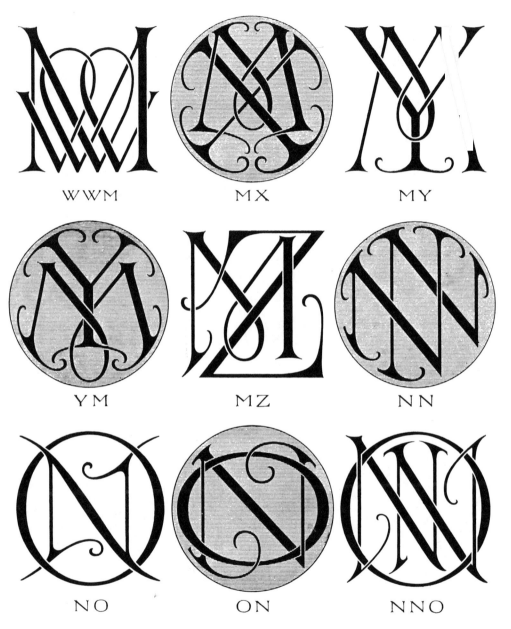

WWM MX MY

YM MZ NN

NO ON NNO

PLATE XCI—MW, MX, MY, MZ, NN, NO

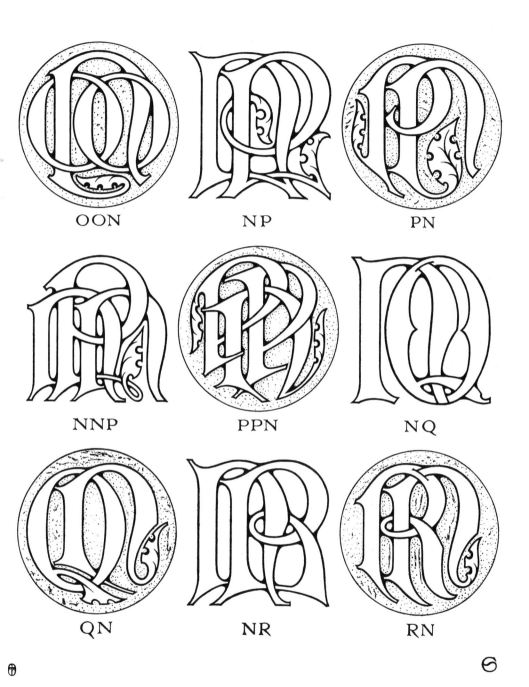

OON NP PN

NNP PPN NQ

QN NR RN

PLATE XCII—NO, NP, NQ, NR

NNR RRN N S

SN NNS SSN

NT TN NNT

PLATE XCIII—NR, NS, NT

TTN NU UN

NNU UUN NV

VN NW WN

PLATE XCIV—NT, NU, NV, NW

NNW WWN NX

NY NZ OO

OP PO OOP

PLATE XCV—NW, NX, NY, NZ, OO, OP

PPO OQ OR

RO OOR RRO

OS SO OOS

PLATE XCVI—OP, OQ, OR, OS

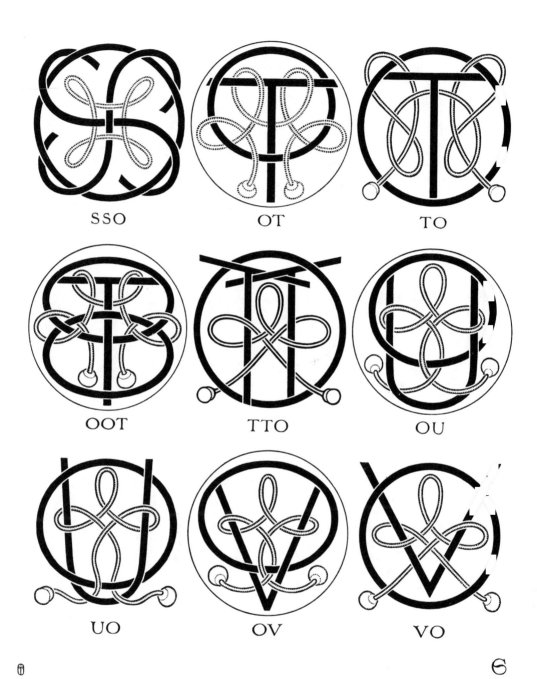

SSO　　　　OT　　　　TO

OOT　　　　TTO　　　　OU

UO　　　　OV　　　　VO

PLATE XCVII—OS, OT, OU, OV

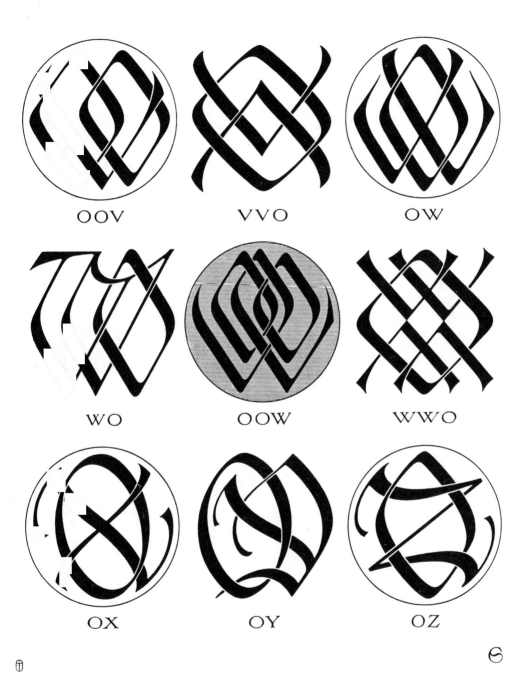

OOV VVO OW

WO OOW WWO

OX OY OZ

PLATE XCVIII—OV, OW, OX, OY, OZ

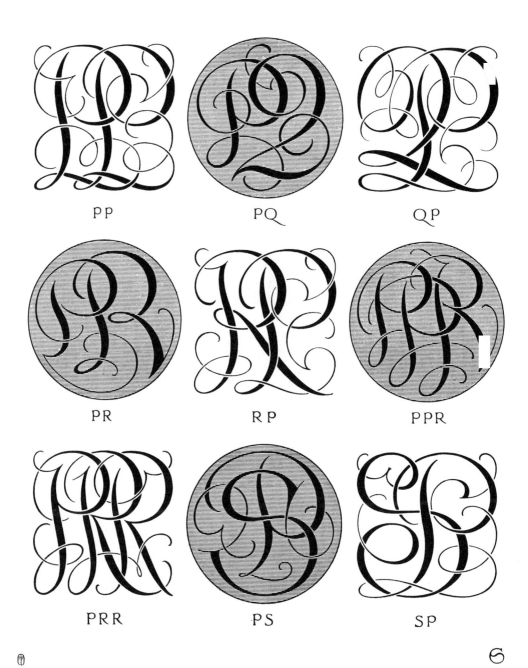

PP PQ QP

PR RP PPR

PRR PS SP

PLATE XCIX—PP, PQ, PR, PS

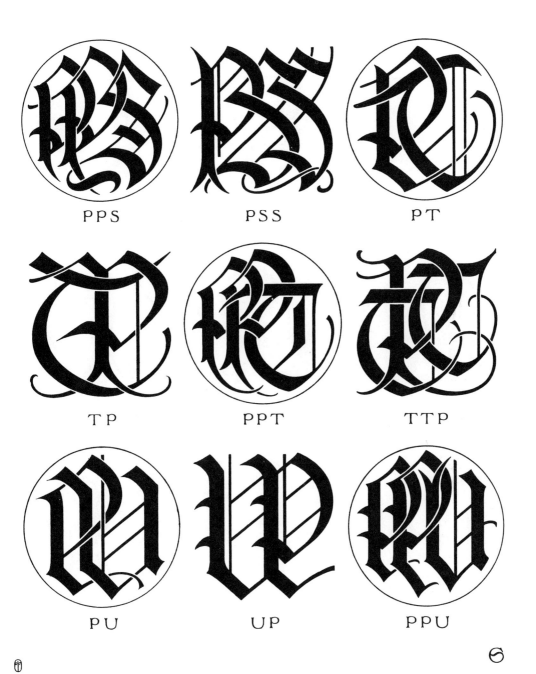

PPS PSS PT

TP PPT TTP

PU UP PPU

PLATE C—PS, PT, PU

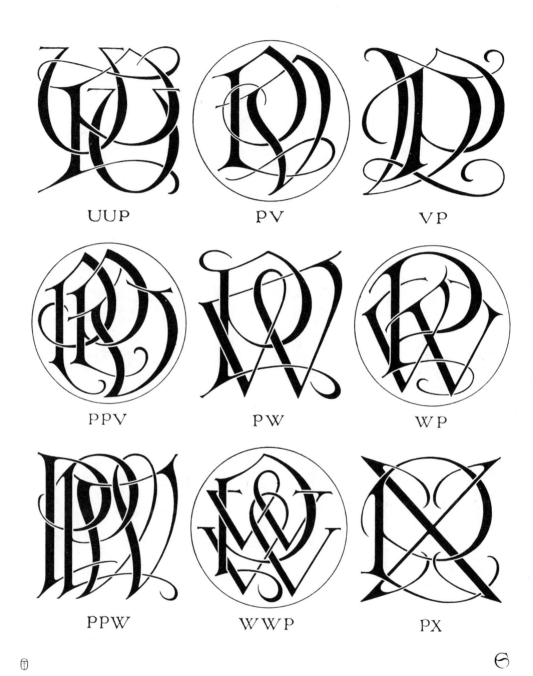

UUP PV VP

PPV PW WP

PPW WWP PX

PLATE CI—PU, PV, PW, PX

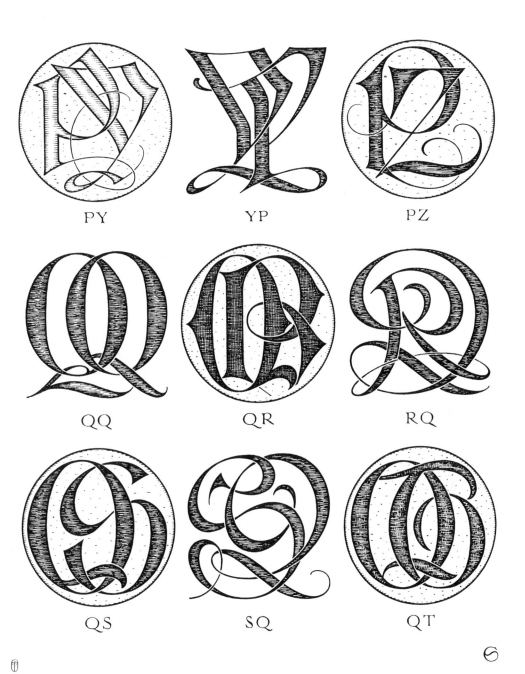

PY YP PZ

QQ QR RQ

QS SQ QT

PLATE CII—PY, PZ, QQ, QR, QS, QT

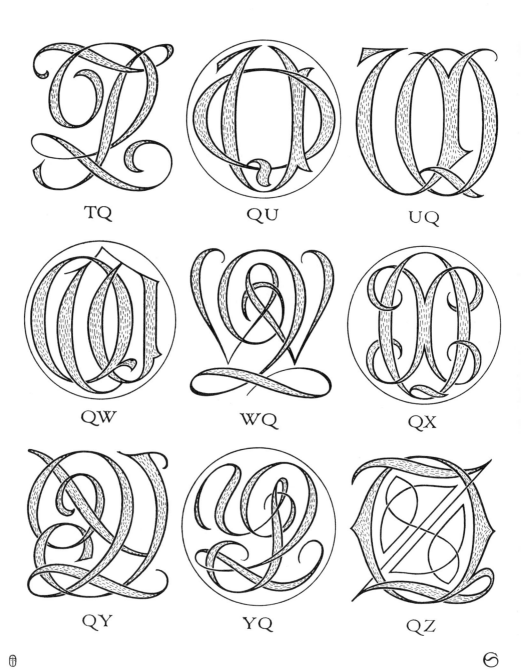

TQ QU UQ

QW WQ QX

QY YQ QZ

PLATE CIII—QT, QU, QW, QX, QY, QZ

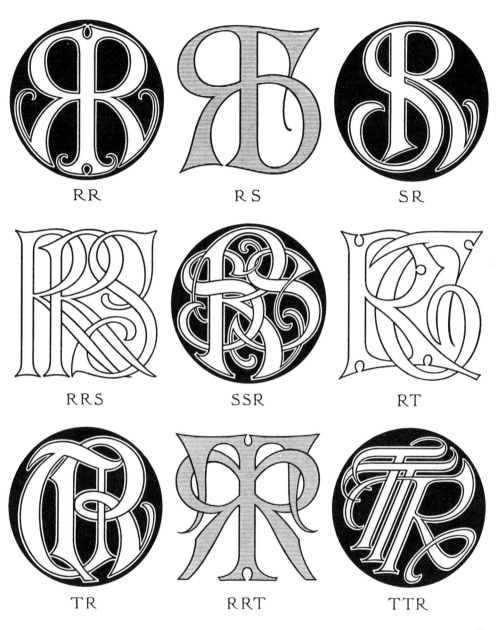

RR RS SR

RRS SSR RT

TR RRT TTR

PLATE CIV—RR, RS, RT

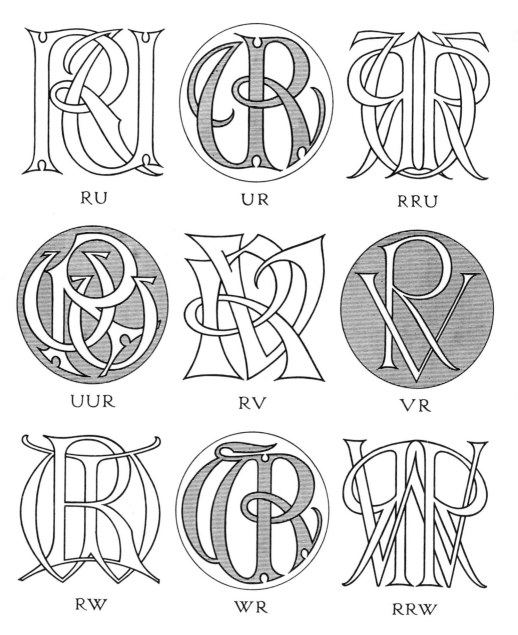

RU UR RRU

UUR RV VR

RW WR RRW

PLATE CV—RU, RV, RW

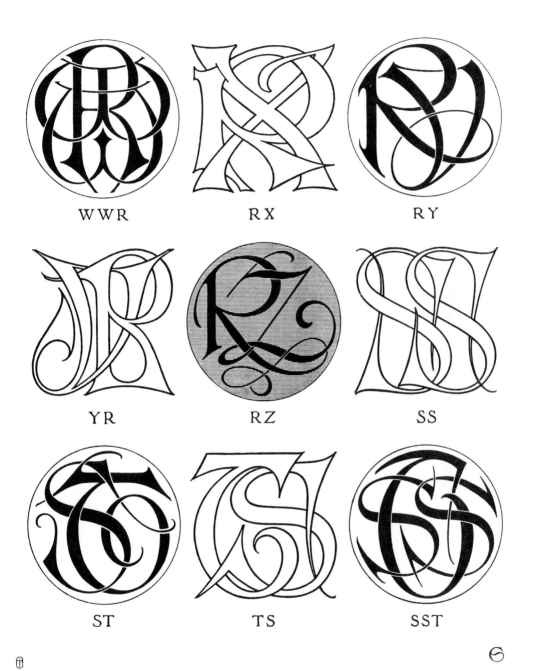

WWR RX RY

YR RZ SS

ST TS SST

PLATE CVI—RW, RX, RY, RZ, SS, ST

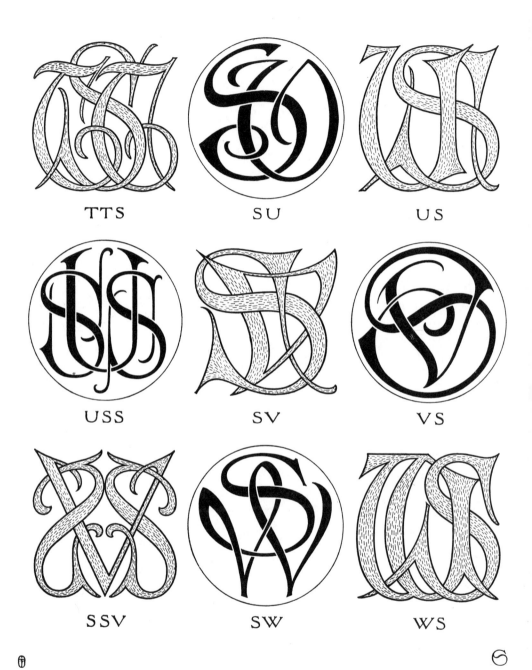

TTS SU US

USS SV VS

SSV SW WS

PLATE CVII—ST, SU, SV, SW

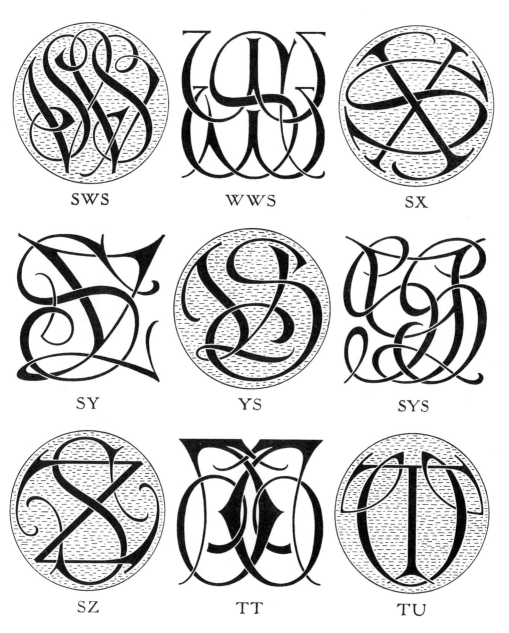

SWS WWS SX

SY YS SYS

SZ TT TU

PLATE CVIII—SW, SX, SY, SZ, TT, TU

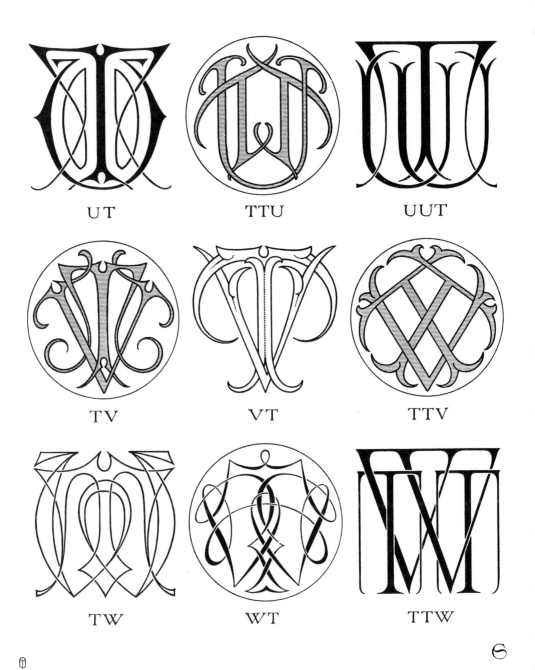

UT TTU UUT

TV VT TTV

TW WT TTW

PLATE CIX—TU, TV, TW

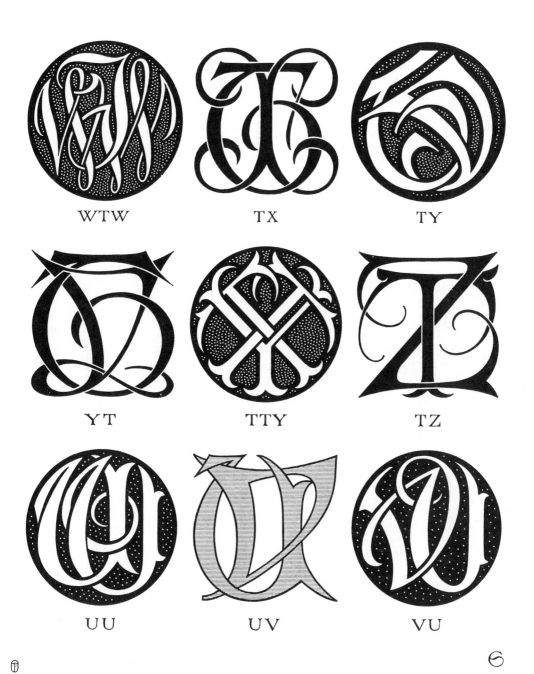

WTW TX TY

YT TTY TZ

UU UV VU

PLATE CX—TW, TX, TY, TZ, UU, UV

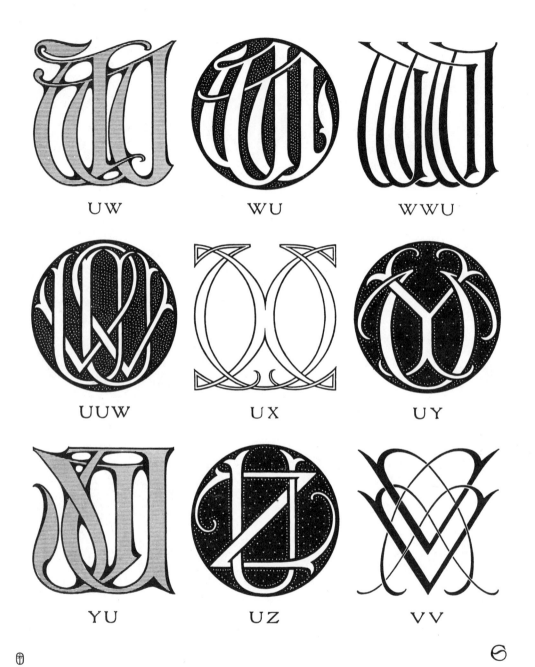

UW WU WWU

UUW UX UY

YU UZ VV

PLATE CXI—UW, UX, UY, UZ, VV

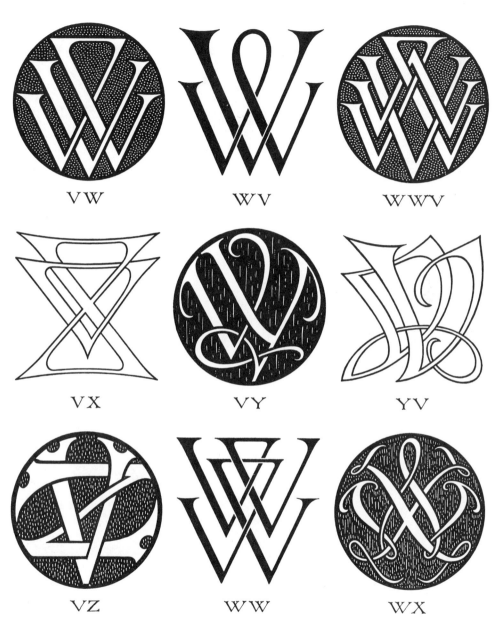

VW WV WWV

VX VY YV

VZ WW WX

PLATE CXII—VW, VX, VY, VZ, WW, WX

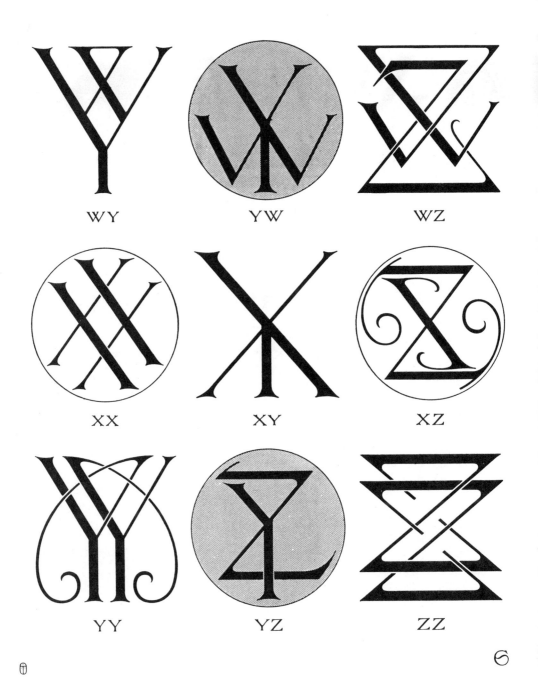

WY YW WZ

XX XY XZ

YY YZ ZZ

PLATE CXIII—WY, WZ, XX, XY, XZ, YY, YZ, ZZ

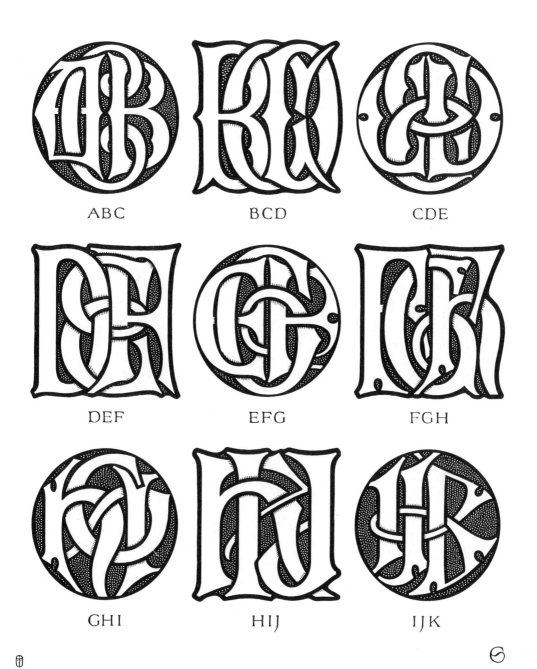

ABC BCD CDE

DEF EFG FGH

GHI HIJ IJK

PLATE CXIV—THREE-LETTER CIPHERS

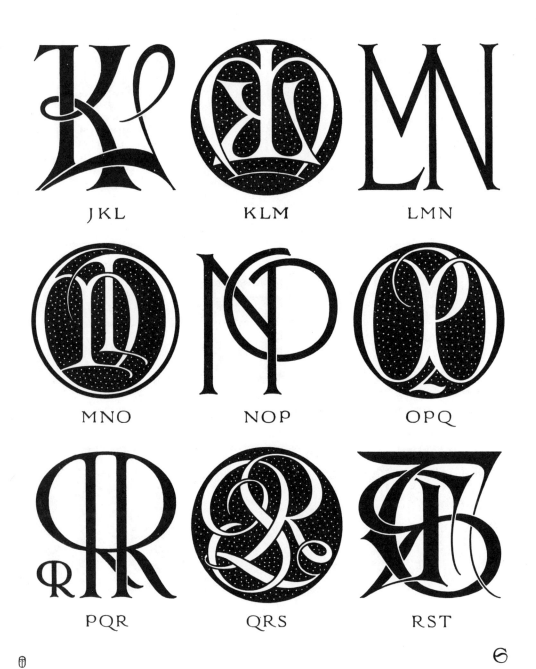

JKL KLM LMN

MNO NOP OPQ

PQR QRS RST

PLATE CXV—THREE-LETTER MONOGRAMS

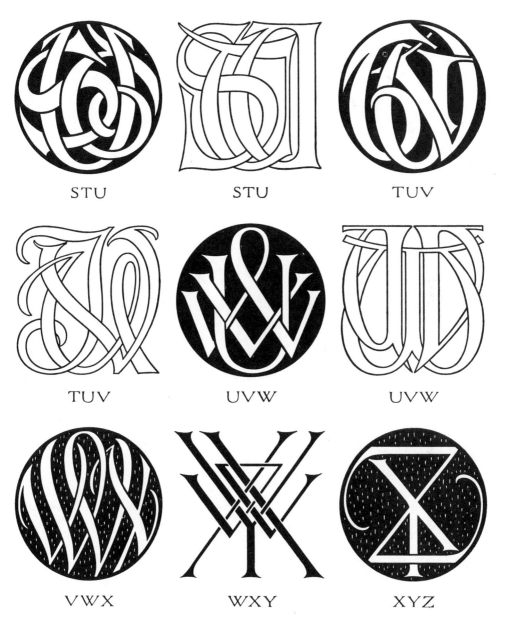

STU STU TUV

TUV UVW UVW

VWX WXY XYZ

PLATE CXVI—THREE-LETTER CIPHERS AND MONOGRAM

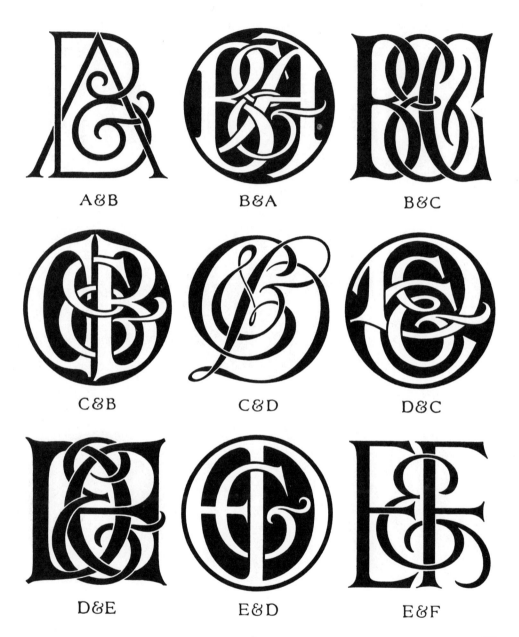

A&B B&A B&C

C&B C&D D&C

D&E E&D E&F

PLATE CXVII—TWO LETTERS WITH THE &

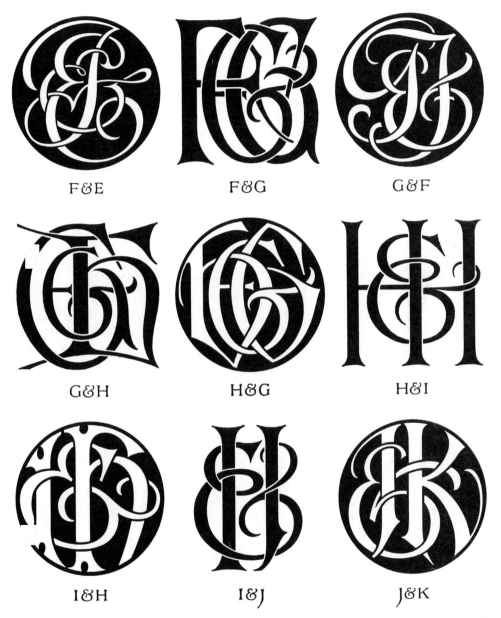

F&E F&G G&F

G&H H&G H&I

I&H I&J J&K

PLATE CXVIII—TWO LETTERS WITH THE &

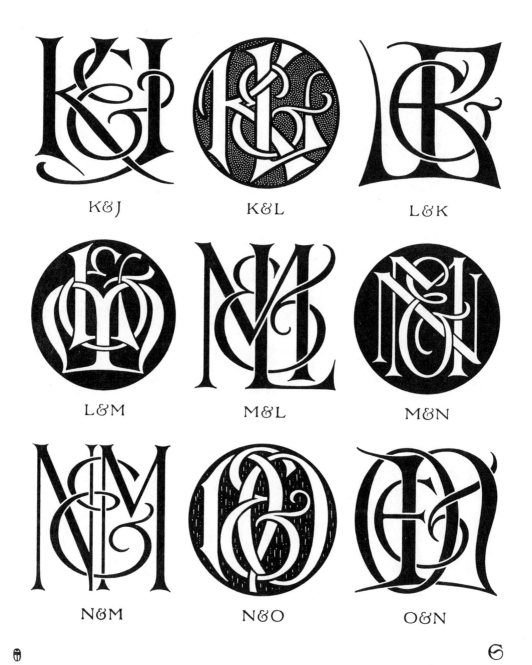

K&J

K&L

L&K

L&M

M&L

M&N

N&M

N&O

O&N

PLATE CXIX—TWO LETTERS WITH THE &

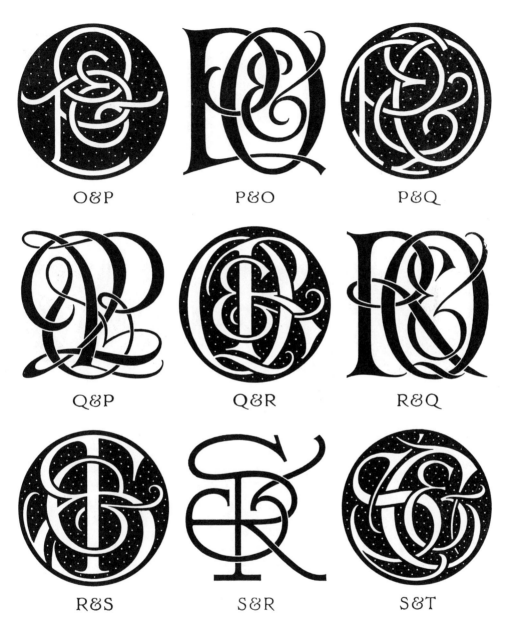

O&P	P&O	P&Q
Q&P	Q&R	R&Q
R&S	S&R	S&T

PLATE CXX—TWO LETTERS WITH THE &

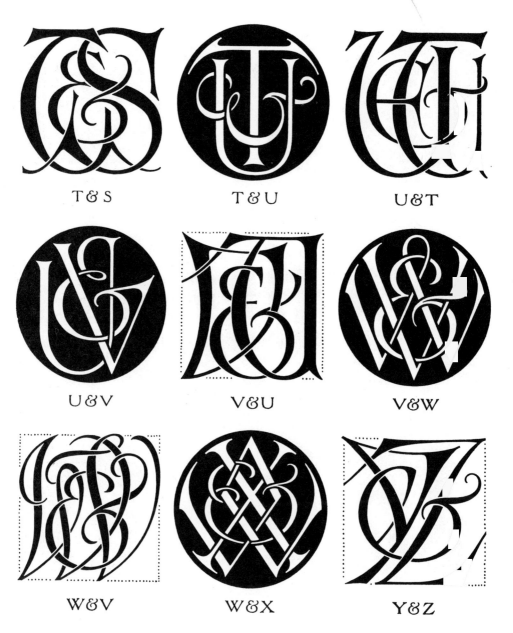

T&S T&U U&T

U&V V&U V&W

W&V W&X Y&Z

PLATE CXXI—TWO LETTERS WITH THE &

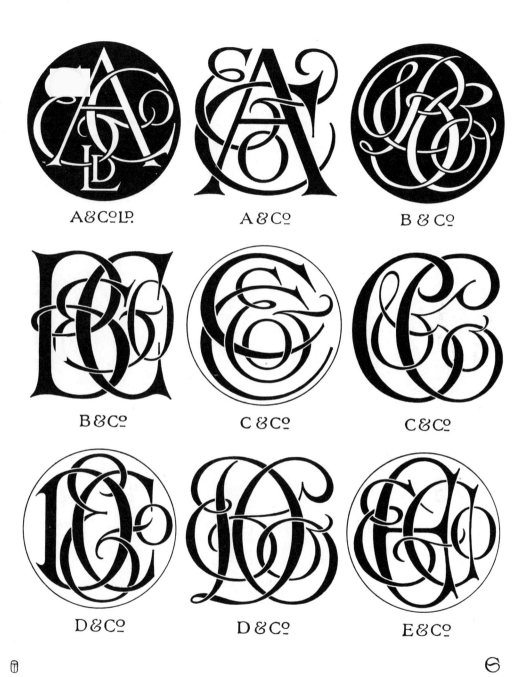

A&C°L°. A&C° B & C°

B&C° C & C° C&C°

D&C° D&C° E&C°

PLATE CXXII—COMPANY CIPHERS

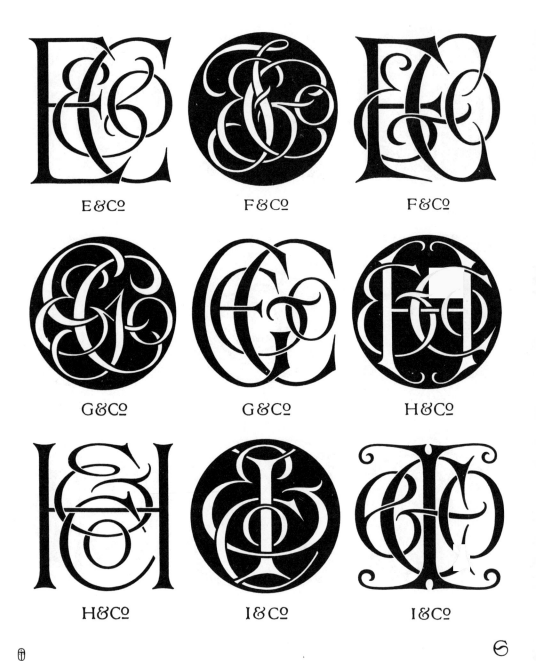

E&Cọ F&Cọ F&Cọ

G&Cọ G&Cọ H&Cọ

H&Cọ I&Cọ I&Cọ

PLATE CXXIII—COMPANY CIPHERS

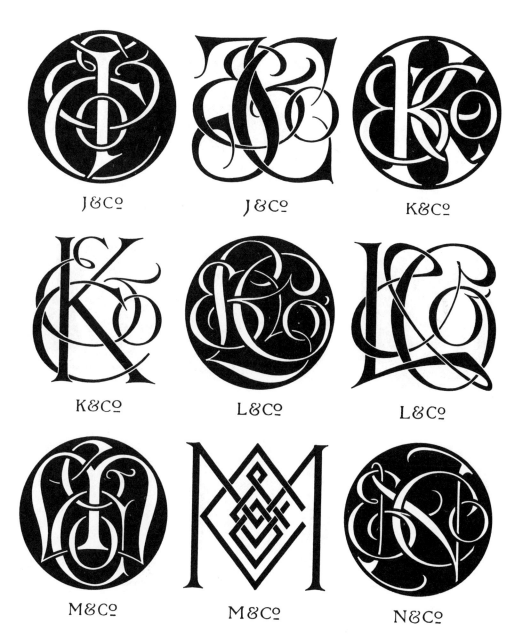

J&Cº J&Cº K&Cº

K&Cº L&Cº L&Cº

M&Cº M&Cº N&Cº

PLATE CXXIV—COMPANY CIPHERS

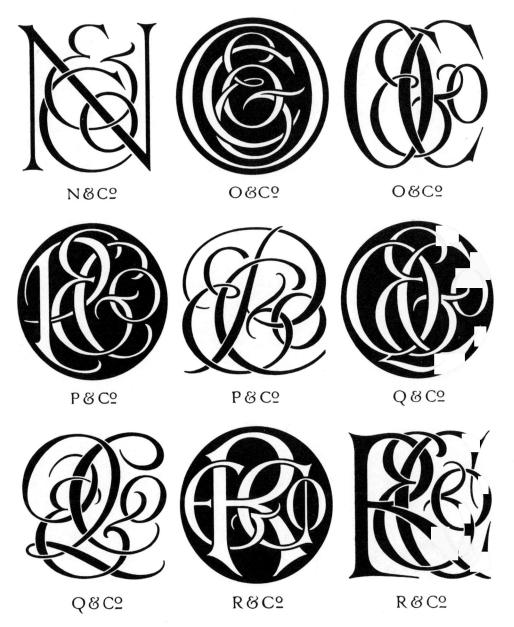

N&Co. O&Co. O&Co.

P&Co. P&Co. Q&Co.

Q&Co. R&Co. R&Co.

PLATE CXXV—COMPANY CIPHERS

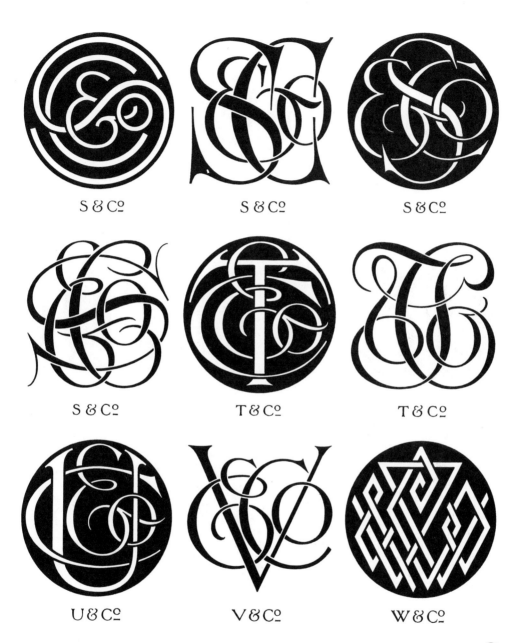

S & Cº S & Cº S & Cº

S & Cº T & Cº T & Cº

U & Cº V & Cº W & Cº

PLATE CXXVI—COMPANY CIPHERS

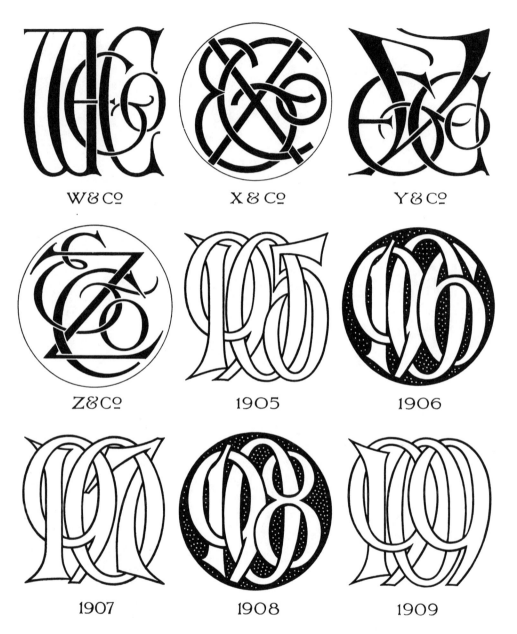

W & Co X & Co Y & Co

Z & Co 1905 1906

1907 1908 1909

PLATE CXXVII—COMPANY CIPHERS, YEARS

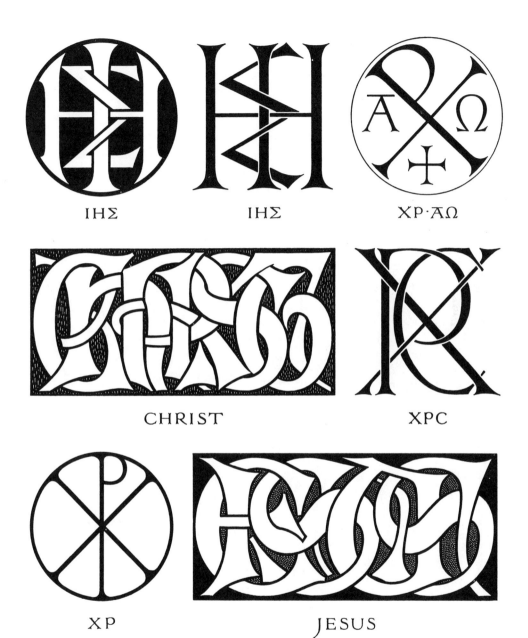

IHΣ IHΣ XP·ĀΩ

CHRIST XPC

XP JESUS

PLATE CXXVIII—SACRED DEVICES

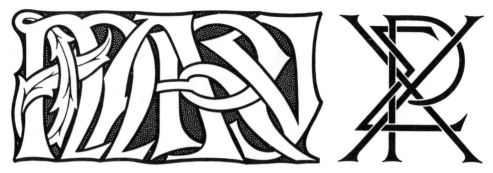

MARY XPΣ

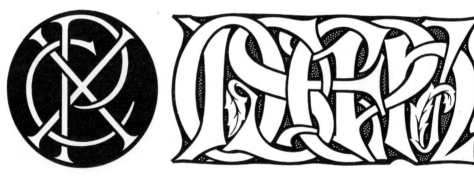

XPC JOSEPH

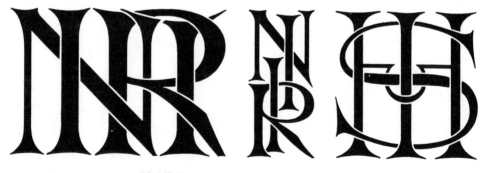

INRI IHS

PLATE CXXIX—SACRED DEVICES

AΩ

INRI

ALPHA

AΩ

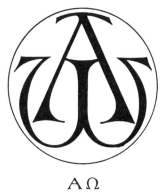

AΩ

OMEGA

PLATE CXXX—SACRED DEVICES

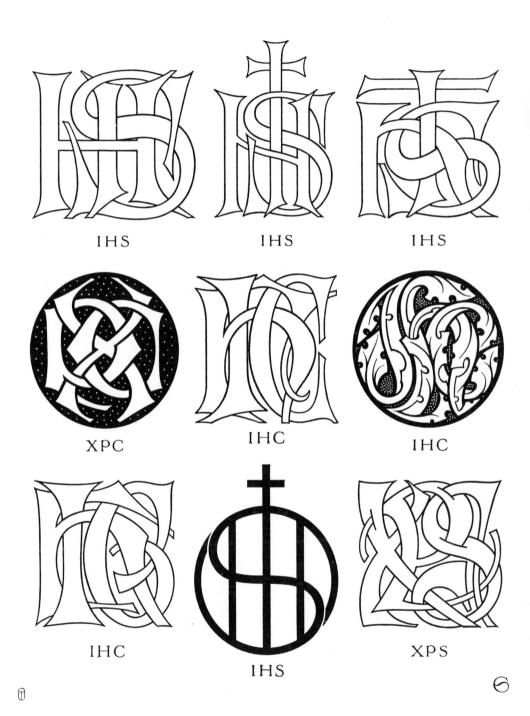

IHS IHS IHS

XPC IHC IHC

IHC IHS XPS

PLATE CXXXI—SACRED DEVICES

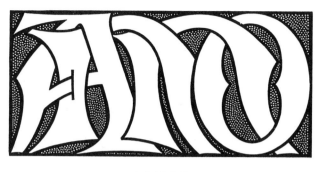

ANNO

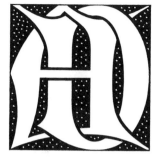

AD

AD

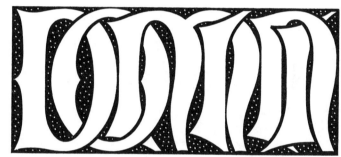

DOMINI

AD

AD

AD

PLATE CXXXII—SACRED DEVICES

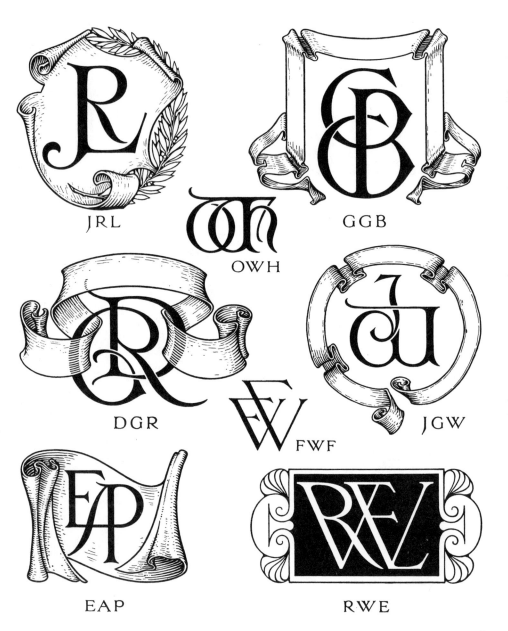

JRL

GGB

OWH

DGR

FWF

JGW

EAP

RWE

PLATE CXXXIII—LABELS AND MONOGRAMS

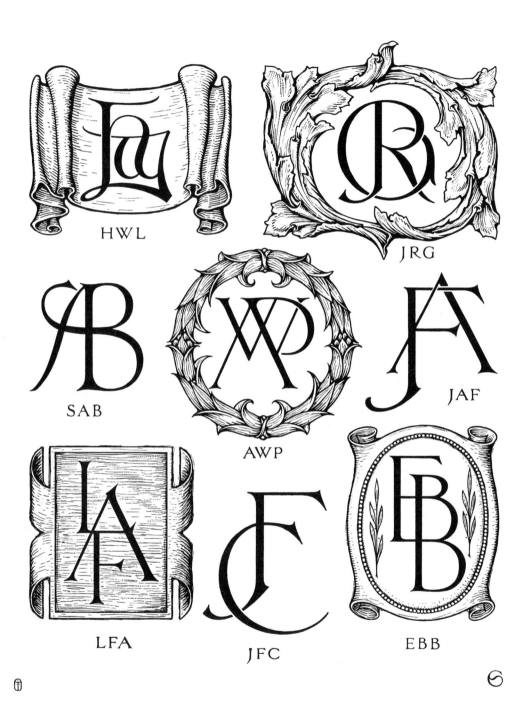

HWL

JRG

SAB

AWP

JAF

LFA

JFC

EBB

PLATE CXXXIV—LABELS AND MONOGRAMS

GLORIA IN EX-

CELSIS DEO LAS

DEO A ANO

DOMIN ✠ 1906

DEO VOLENE V

PLATE CXXXV—SACRED DEVICES